POSTCARD HISTORY SERIES

West Chester

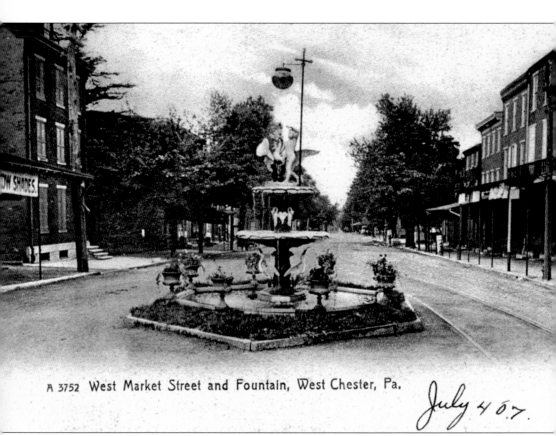

A 3752 West Market Street and Fountain, West Chester, Pa.

July 4 ó.7.

The hub of commerce for West Chester, Pennsylvania, and most villages in the early days of the nation was the market. Shown in this postcard is Market Street with its impressive fountain. The Everhart Fountain was later removed to Everhart's Grove and has since disappeared. Renowned architect Thomas U. Walter was hired to design the market building in the 1800s and was paid $8 for his work. The date on this postcard is a patriotic July 4, 1907. At the time, Market Street was the center of commerce, as one store advertises window shades for sale.

POSTCARD HISTORY SERIES

West Chester

Bruce Edward Mowday

ARCADIA
PUBLISHING

Published by Arcadia Publishing
Charleston SC, Chicago IL, Portsmouth NH, San Francisco CA

Printed in the United States of America

Library of Congress Catalog Card Number: 2005924382

For all general information contact Arcadia Publishing at:
Telephone 843-853-2070
Fax 843-853-0044
E-mail sales@arcadiapublishing.com
For customer service and orders:
Toll-Free 1-888-313-2665

Visit us on the Internet at www.arcadiapublishing.com

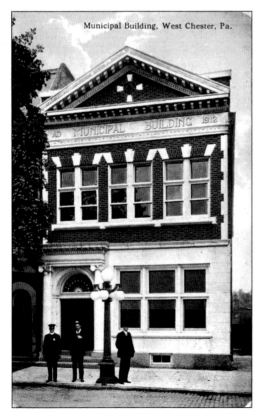

West Chester was incorporated as a borough in 1799, and the borough government moved into its new municipal building in 1912, as the date on the building in this postcard indicates. The headquarters housed not only elected governmental representatives but also the police department. Two uniformed policemen are shown in this card postmarked 1914. The borough outgrew the High Street building in 1978, and now a new Turk's Head Inn restaurant occupies the site.

CONTENTS

Acknowledgments 6

Introduction 7

1. Around West Chester 9

2. Street Scenes 27

3. Religious Institutions 37

4. The Normal School 49

5. Commerce 69

6. Parks 83

7. People and Places 91

8. Parker Postcards 111

ACKNOWLEDGMENTS

This postcard history book of West Chester, Pennsylvania, came to life through the encouragement of a number of people, including staff members of Arcadia Publishing. After working to produce three other books, including *Coatesville*, *Downingtown*, and *Along the Brandywine River*, the company asked me if I had another subject for a book involving my section of the country: Chester County, Pennsylvania. West Chester was the obvious community for a postcard publication. Even though Paul Rodebaugh and Martha Carson Gentry wrote a pictorial history of the town in 1997 for Arcadia, a postcard book of West Chester was warranted because the town, rich with heritage, has been the subject of numerous postcards.

The postcards for this book are mainly taken from my own collection, amassed over a number of years attending postcard, paper, and antique shows and sales throughout the region. I have a few favorite dealers, including Dolores and Leon Rowe of Kennett Square, who always seem to have unique cards of the area. Postal historian William Schultz, who lives just north of West Chester, has also contributed a portion of his large postcard collection to this book. Bill has an impressive assemblage of not only postcards but also postal history. His cards add immensely to the completeness of this book.

The acknowledgment for my wife, Katherine Harlan, is twofold. She is a first-rate editor who always finds my mistakes, and she offers great assistance at the shows we attend. Faced with what looks like a sea of postcard dealers at some of the major shows, Katherine pitches in and hunts for cards on certain subjects, in this case West Chester. While I examine some of the dealers' collections, she will scour others for the sought-after cards and keep them in one section until I have a chance to review them. Other members of my family, especially my daughters Megan and Melissa, keep an eye out for possible new additions for my collections. For this book, one Sunday afternoon, Melissa called from a New Jersey antique shop to ask if I had the unique West Chester cards she had discovered there.

As a member of the board of trustees of the Chester County Historical Society, I have access to the best historical research facility in Chester County. Besides housing many historical papers associated with the county, the organization has an outstanding pictorial library. Pam Powell of photograph archives and Diane Rofini of the library are always extremely helpful. One of the topics of this book deals with the S. J. Parker and Son postcards made in West Chester. One of Mr. Parker's relatives, William B. Parker, serves on the board with me and shared his knowledge of his relative's postcard business.

A special thank-you goes to everyone who loves West Chester and Chester County history and keeps it alive for the next generation. Since I have lived in and spent a large portion of my career working in West Chester, I know and feel affection for the town once called Turk's Head.

INTRODUCTION

West Chester, the county seat of one of William Penn's original three counties of Pennsylvania, is rich in history. Long before Penn and members of the Society of Friends settled in the community at first known as Turk's Head, members of the Lenape and other American Indian nations lived in the area, especially where the Brandywine River flows to the west of the town.

The settlement was first named for a tavern that sported a popular sign of the times, a Turk's head. The town has never totally abandoned the first designation; a local music festival uses Turk's Head, and a thriving restaurant on High Street, housed in the former borough hall, goes by the same name. A Turk's Head tavern sign also resides in the Chester County Historical Society building, located in West Chester.

As the new nation was fighting for independence, Turk's Head played a role in the important Philadelphia campaign of 1777. After the largest land battle of the American Revolution was fought at nearby Chadds Ford on September 11 of that year, the wounded were brought to Turk's Head for care at a school at the intersection of High and Gay Streets. After the Battle of Brandywine, a fight continued through the streets of town between troops of Gen. George Washington and Gen. William Howe. West Chester also took part in the American Civil War, sending troops to fight in Lincoln's army. In fact, Abraham Lincoln's campaign biography was printed in West Chester in what is now known as the Lincoln Building.

When the original Chester County was to be split into two—Chester and Delaware Counties— Chester residents did not like the idea of the county seat moving to West Chester. In 1785, Maj. John Harper, a Chester saloon keeper, led an armed detachment on the new Chester County Courthouse, still under construction, with the intent of destroying the structure. The Chester men brought a cannon, muskets, and a barrel of whiskey. Col. John Hannum, who had fought at Brandywine, led local men to stop Major Harper. Cooler heads prevailed, maybe with the aid of the whiskey, before shots were fired, and the building of the courthouse continued.

As the town grew, renowned architect Thomas U. Walter was hired to design some of West Chester's prominent buildings. Besides the courthouse, his work is visible today in bank and church buildings and Horticultural Hall, now a part of the Chester County Historical Society. Walter is known for designing the Capitol's dome in Washington, D.C.

West Chester's position as the center of county government led to a tradition of legal excellence, as a number of attorneys who practiced in West Chester went on to serve on higher state and federal courts. Today, many of the offices in West Chester are related to the practice of law, and as this book goes to press, a new justice center is being constructed on Market Street to accommodate the growing population of Chester County, now approaching a half-million people.

Educational institutions have played an integral part in the development of West Chester. A number of private schools operated in the 19th century. Students today are educated in several facilities, including both private and public schools.

The major postsecondary educational institution has gone by a number of different names in its history, including the West Chester Normal School, West Chester State Teachers' College, and now West Chester University. The school, according to a published history, traces its origin to September 28, 1811, when Dr. William Darlington, a West Chester native and nationally known botanist, and a group of interested men met at the courthouse to establish an educational institution. Through legislation by the commonwealth of Pennsylvania, "normal schools" were established to become "model schools" for the education of students, especially for teachers. Postcards in this book call the institution both a normal school and model school. Today, West Chester University, led by president Madeleine Wing Adler, plays an important role locally.

West Chester's religious community is also strong, as different churches representing many denominations operate in the town. In 1999, when the town celebrated the bicentennial of its founding, 25 different religious organizations were identified. The Society of Friends, the Quakers, helped to establish West Chester and many of the surrounding communities and remains a major influence.

The Chester County Art Association and the Chester County Historical Society keep art and culture alive in the community. Through the years, West Chester has been home to composer Samuel Barber, artist Horace Pippin, and many other talented artists. West Chester residents have participated in many different sports, some on the national level in both major-league baseball and the National Football League.

West Chester is also a thriving business center. Many innovative business owners founded companies in the town, including the Denney Tag Company by brothers Samuel and H. Denney and the Sharples Separator Works, manufacturer of the dairy industry's first tubular cream separator. The sprawling Sharples facility was considered one of the country's most significant industrial production plants of the late 19th century. Today, the downtown business area hosts many thriving shops and is known for a variety of fine restaurants.

Those who have lived, worked, or gained an education in West Chester have a special affinity for the town. As this introduction indicates, it has a rich and varied history. This postcard book endeavors to tell a portion of that history.

One

AROUND WEST CHESTER

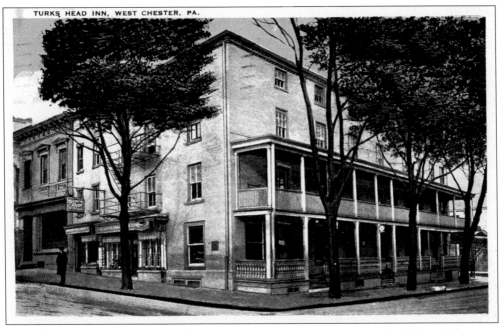

TURKS HEAD INN, WEST CHESTER, PA.

West Chester's first identity came from a tavern and its sign depicting a Turk's head. The town long ago changed its name to West Chester, but the Turk's Head identity has never been lost. The tavern's name was used by a hotel and tavern, as shown in the above postcard. Today, a restaurant on High Street in the old municipal building calls itself the Turk's Head Inn.

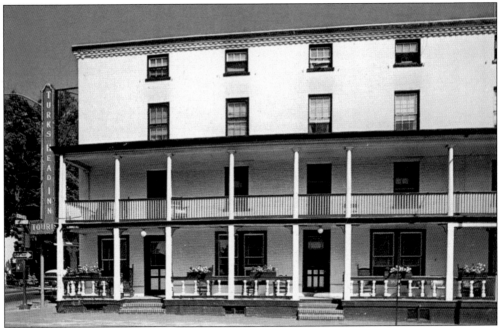

A later view of the Turk's Head Inn is shown above. The building at High and Market Streets no longer exists. Another local landmark hotel was the Green Tree Inn, pictured below. It was located at another thriving corner of town, Gay and High Streets. The postcard on the cover of this book also portrays the Green Tree Inn. The card on this page was produced by A. Henry, one of several West Chester postcard manufacturers. Henry's business was situated a block away, at 18 North Church Street.

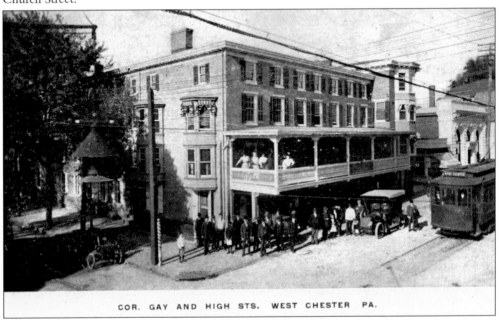

COR. GAY AND HIGH STS. WEST CHESTER PA.

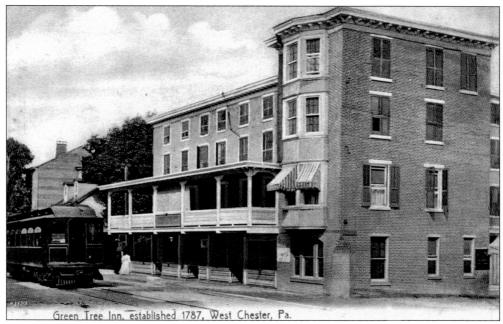

Green Tree Inn, established 1787, West Chester, Pa.

One of the more prolific postcard manufacturers was S. J. Parker and Son. The company produced more than 350 cards. The Parker store, where dry goods were sold, was located on Gay Street. On this page are two Parker views of the Green Tree Inn, established in 1787. A trolley car travels above, and a horse-drawn wagon below. The sign to the right reads, "Drink Moxie, very healthful."

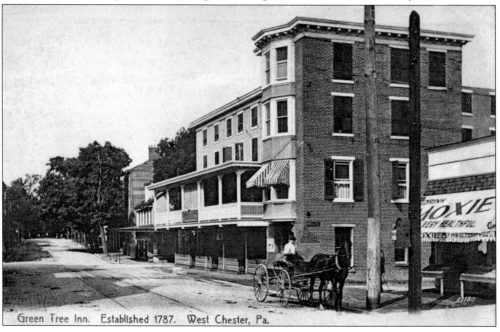

Green Tree Inn. Established 1787. West Chester, Pa.

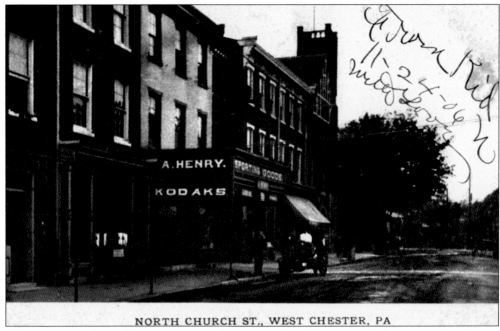

NORTH CHURCH ST., WEST CHESTER, PA

The two postcards on this page show the locations of the Henry and Parker postcard studios in West Chester. Above is a section of North Church Street showing the A. Henry sign. Sporting goods were also sold in the building. Below, the S.J. Parker and Son business appears to the extreme right. The location is Gay Street, west of High Street. The Henry postcard has a 1906 postmark, while the Parker card bears one from 1912.

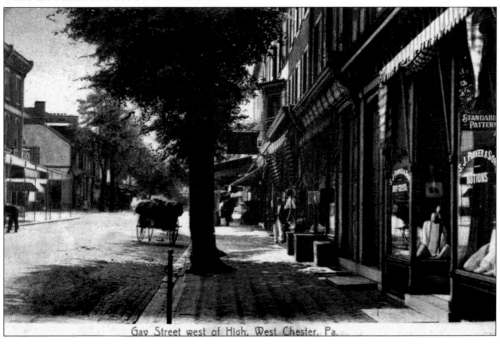

Gay Street west of High, West Chester, Pa.

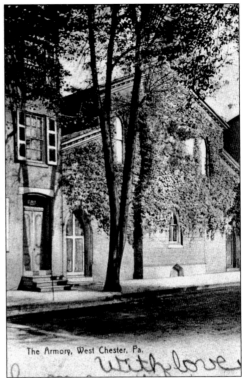

The Armory, West Chester, Pa.

with love

The armory building, shown to the right, was the subject of another S. J. Parker and Son card. The building was situated on West Gay Street near St. Agnes Church. Its original use was as an Episcopal church in 1838. The building no longer stands. The postcard below, with a 1912 postmark, shows a "view of New Trust building," located on the corner of High and Market Streets. The columns to the right belong to the Chester County Courthouse.

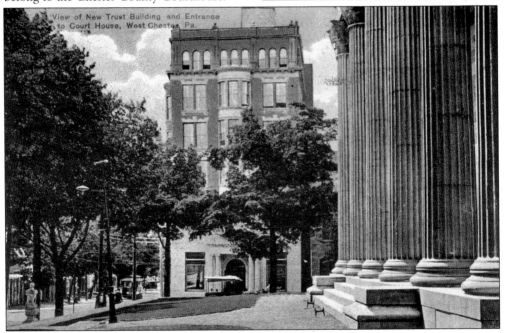

View of New Trust Building and Entrance to Court House, West Chester, Pa.

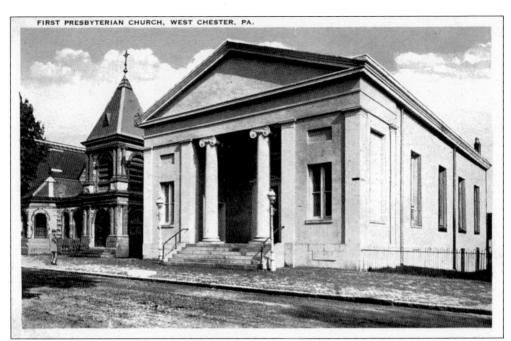

The works of architect Thomas U. Walter can be seen in the buildings of these two postcards. Walter was 27 years old when he designed the First Presbyterian Church, shown above. Walter also designed the National Bank of Chester County, pictured below. Two men appear in front of the building. To the extreme right is the First National Bank of West Chester, now the First National Bank of Chester County. Walter also designed the dome of the Capitol in Washington, D.C.

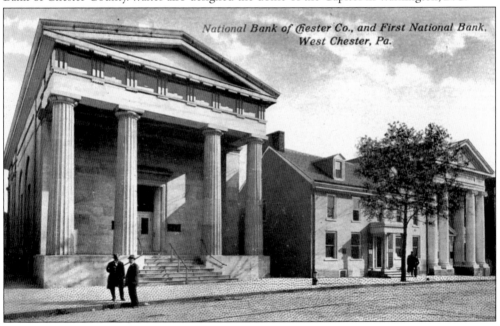

National Bank of Chester Co., and First National Bank, West Chester, Pa.

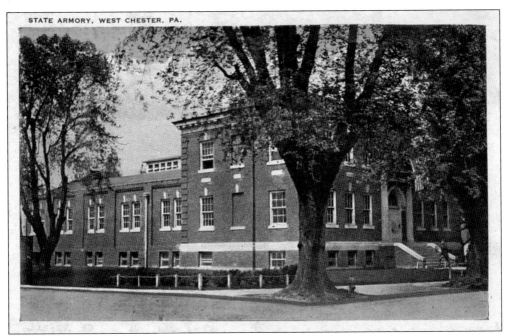

STATE ARMORY, WEST CHESTER, PA.

The postcards on this page depict two government buildings. The card above gives a view of the state armory on High Street, used today by a National Guard unit stationed in West Chester. The postcard below shows "the New Post Office." The postmark of this card is 1907; the structure was built in 1905. The post office still operates, but a larger facility has been constructed outside the borough.

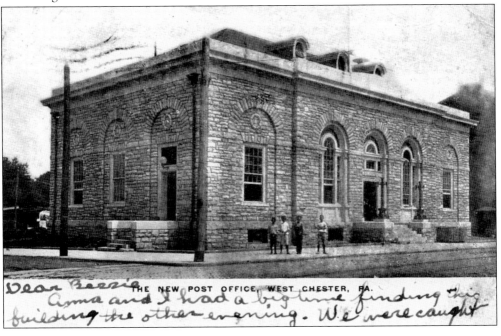

THE NEW POST OFFICE, WEST CHESTER, PA.

Dear Bessie
Anna and I had a big time finding this
building the other evening. We were caught

15

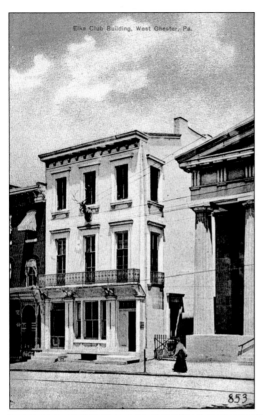

Elks Club Building, West Chester, Pa.

853

The Elks Club building on Market Street appears in the postcard to the left. At one time, the building was used by the Quaker Baking Company as a bake shop and restaurant. The card below, by S. J. Parker and Son with a 1907 postmark, shows the West Chester Public Library, located on the corner of North Church and Lafayette Streets. The library has been used extensively over the years by the citizens of the borough.

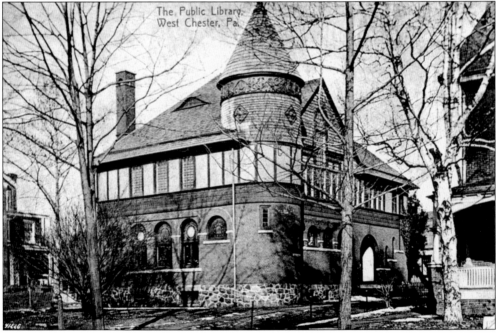

The Public Library, West Chester, Pa.

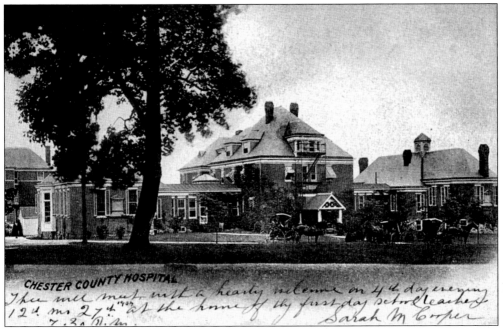

CHESTER COUNTY HOSPITAL

Thee will meet with a hearty welcome on 4th day evening 12th mo 27th at the home of thy first-day school teacher. 7.30 P.m. Sarah M Cooper

Two views of the old Chester County Hospital, at the north side of Marshall Square Park, are shown here. The hospital was constructed in 1893. The card below is dated April 19, 1913, and bears an ink mark on a second-floor window, denoting where a relative of the sender is staying. The card indicates that the relative is recovering. Postcards were the e-mails of the late 19th and early 20th centuries.

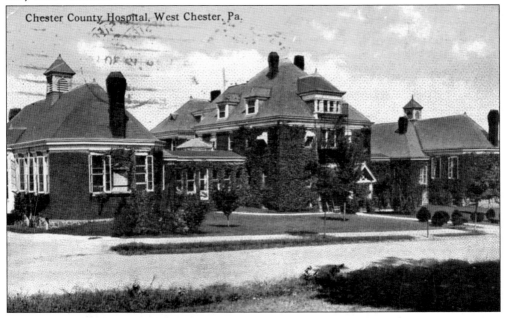

Chester County Hospital, West Chester, Pa.

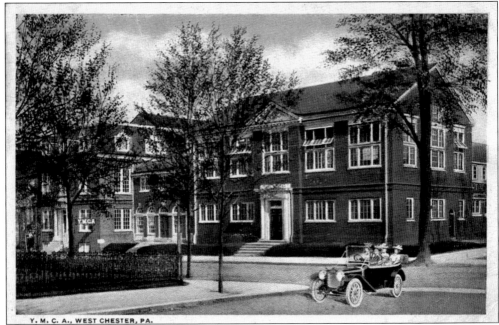

Y. M. C. A., WEST CHESTER, PA.

The above postcard of the YMCA building was used to send a family note. Mailed in 1921, it relayed a message from a grandmother to her grandchild to get well so they could have a long visit. The below postcard reveals the YMCA by moonlight. Built in 1908, the building is located at the corner of Chestnut and High Streets. The portion to the left is now the Chester County Historical Society.

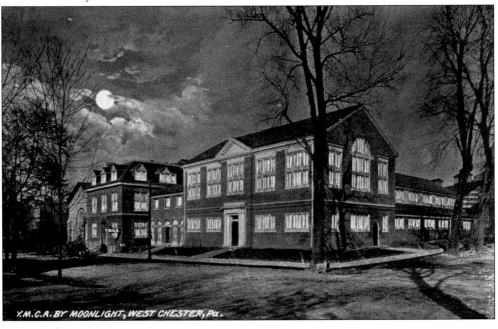

Y.M.C.A. BY MOONLIGHT, WEST CHESTER, Pa.

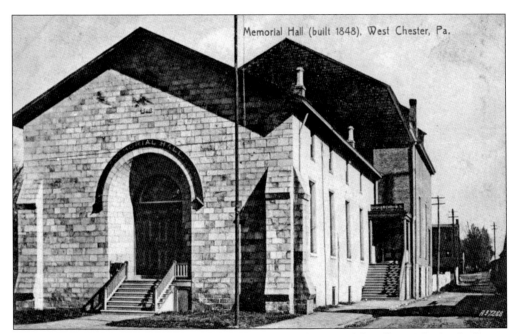

The Memorial Hall, shown in the above postcard from a photograph by Albert Biles, has had many uses since it was designed by Thomas U. Walter and built in 1848. The building was originally called Horticultural Hall. It was home to a Grand Army of the Republic post at one time and is now part of the Chester County Historical Society. The below postcard, with a postmark of 1924, shows the New Century Club on South High Street.

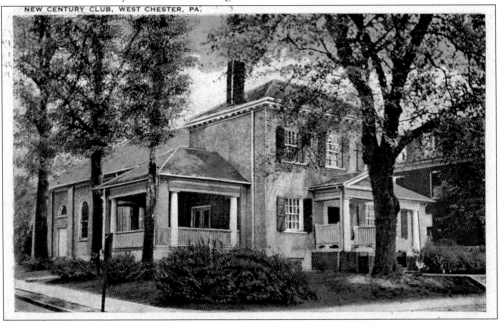

NEW CENTURY CLUB, WEST CHESTER, PA.

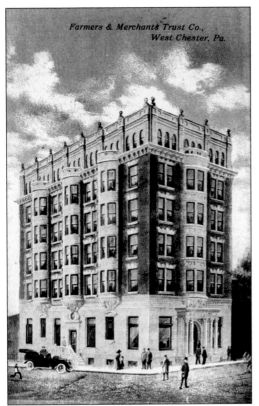

Farmers & Merchants Trust Co.,
West Chester, Pa.

Constructed in 1907, the Farmers and
Merchants Trust Company, pictured to the
left, is an imposing West Chester structure
standing at the corner of Market and High
Streets. This depiction is from the architect's
plans for the building. Below, one block
north, at the intersection of High and Gay
Streets, three modes of transportation are in
use: a wagon, a car, and a trolley.

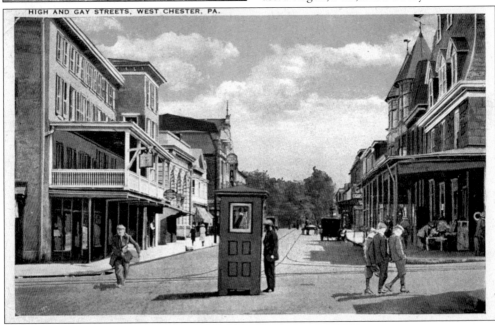

HIGH AND GAY STREETS, WEST CHESTER, PA.

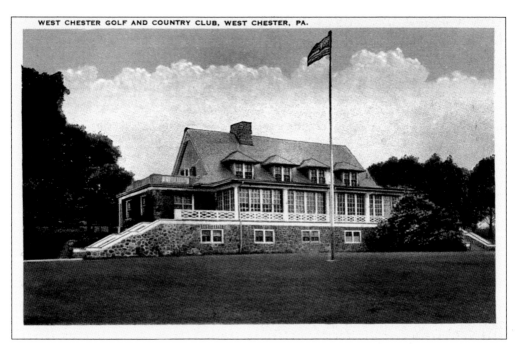

For those entering West Chester from the north and heading south on High Street, the first visible building is that of the West Chester Golf and Country Club. The clubhouse, shown in the postcard above, was built in 1907 and later destroyed by a fire. A larger structure was then built. The Darlington Seminary in West Chester is shown below. Members of the Darlington family provided leadership during the borough's formative years.

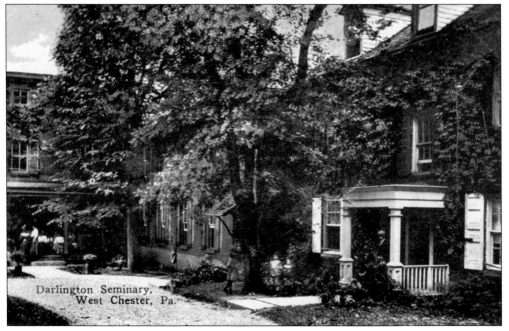

Darlington Seminary, West Chester, Pa.

The above card, postmarked 1941, shows the Marshall Square Sanitarium. Dr. Everett Sperry Barr and Dr. Joseph Scattergood Jr. treated chronic diseases and psychiatric patients there, according to the card. Custodial care was $25 per week. The postcard below depicts the original Barclay Home, located to the east of the Chestnut Street Meeting in West Chester. The card was produced by S. J. Parker and Son.

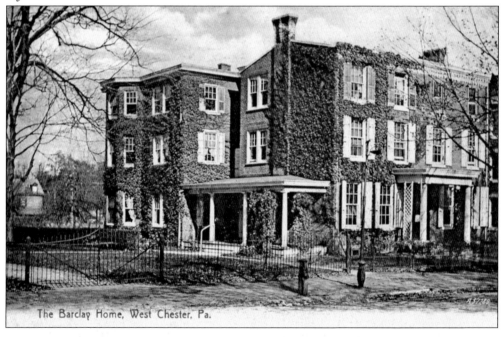

The Barclay Home, West Chester, Pa.

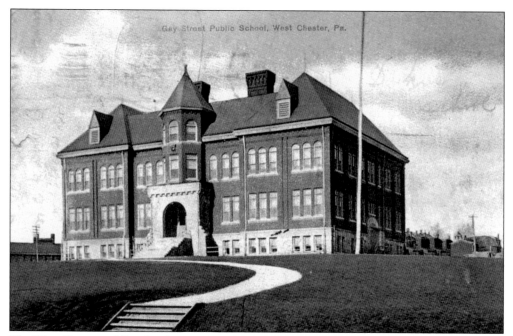

The West Chester public school system has a history of providing quality education to the students of the surrounding area. The above postcard shows the old Gay Street Public School, while the one below reveals what was the "New High School Building." The sender of the below card thanked a friend for kindness when she was sick. "Please know I appreciate it," the writer stated.

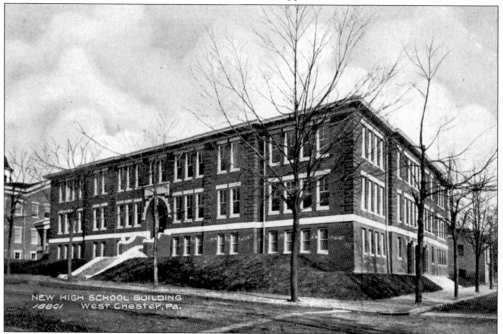

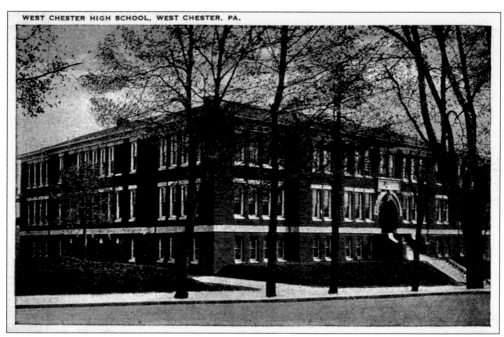

Every community has had its share of devastating fires. The West Chester High School on North Church Street, pictured above, was destroyed during a blaze in December 1947. The fire resulted in the construction of another school on the east side of town. Shown below is the "Public School" of West Chester at High and Price Streets, which was torn down in 1978.

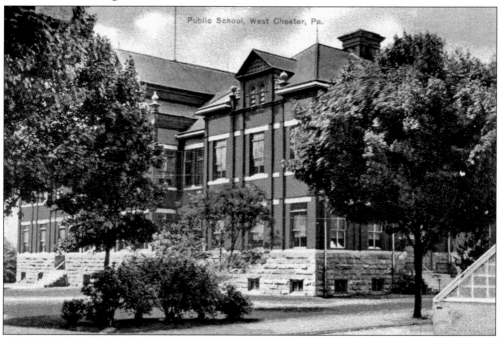

Public School, West Chester, Pa.

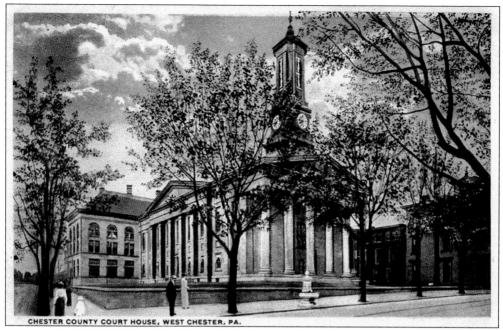

CHESTER COUNTY COURT HOUSE, WEST CHESTER, PA.

This section would not be complete without a postcard of the Chester County Courthouse. The structure has been enlarged over the years, and the above postcard shows the structure before the addition of the Old Glory monument. The below card reveals the 1898 New Century Fountain, then situated on the North High Street land of T. Larry Eyre.

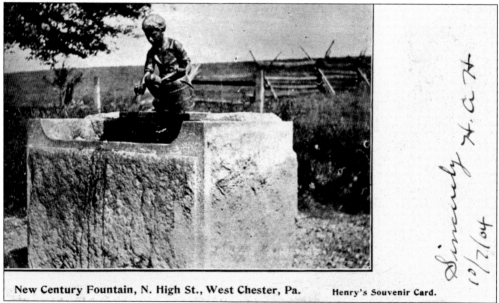

New Century Fountain, N. High St., West Chester, Pa. Henry's Souvenir Card.

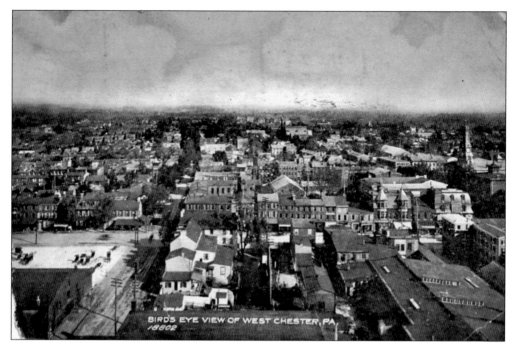

The above bird's-eye view of West Chester was actually taken from the stacks of the old steam plant at the corner of Chestnut and Walnut Streets, near the YMCA building. It shows much of the borough, including the courthouse. The below postcard is titled "Town's-End, West Chester, Pa." The pictured home was occupied by the Shipley family and was located west of the borough on Hillendale Road.

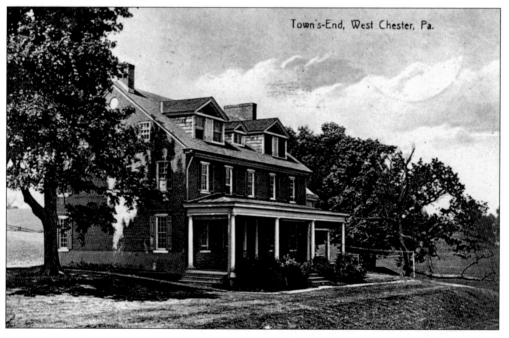

Two

STREET SCENES

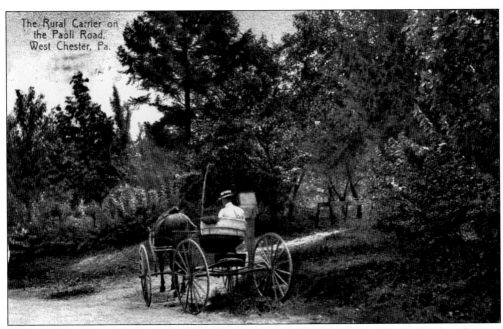

The streetscapes of West Chester Borough are scenic, and many sidewalks are lined with trees. In this S. J. Parker and Son postcard with a 1909 postmark, a rural mail carrier makes deliveries on Paoli Road. The card is believed to have been produced in 1908.

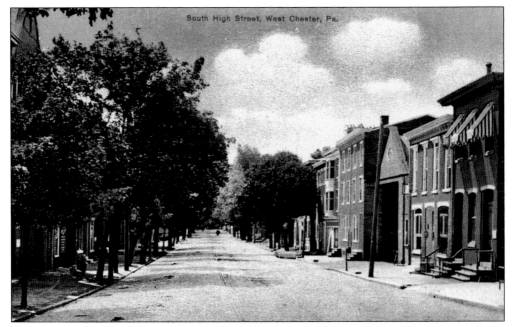

South High Street, West Chester, Pa.

These postcards offer different views of High Street, the main north-south byway through the middle of West Chester. Both of them show the southern part of the road. The above view concentrates on the area around the business section, while the below view looks toward the West Chester Normal School. Groups of people are gathered on the one side of the road.

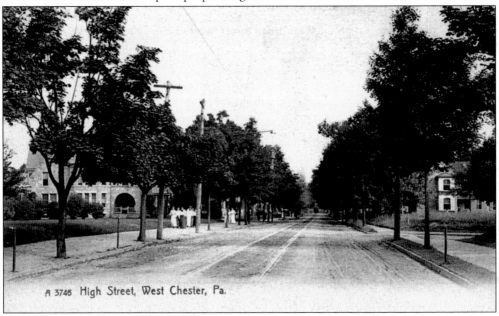

A 3746 High Street, West Chester, Pa.

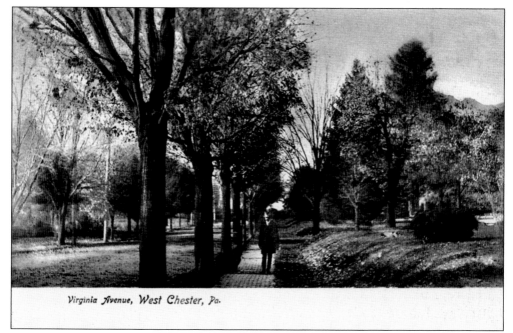

Virginia Avenue, West Chester, Pa.

Virginia Avenue, in the northern section of West Chester, continues to be part of a picturesque residential community. In the above S. J. Parker and Son card, a man walks along a tree-shaded section of Virginia Avenue. The below card, bearing a 1913 postmark, shows some of the stately homes of West Union Street. The buildings in these areas have changed little during the years.

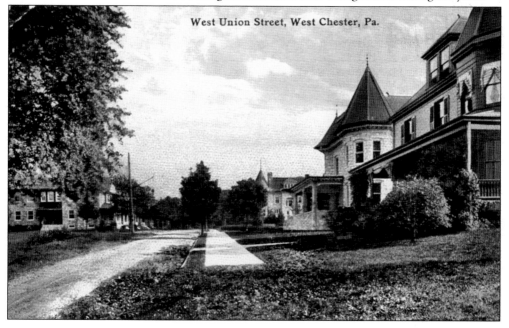

West Union Street, West Chester, Pa.

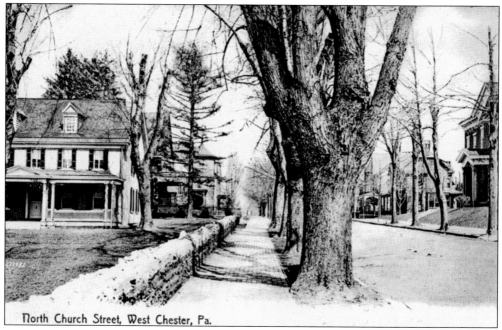

North Church Street, West Chester, Pa.

The above North Church Street view is another S. J. Parker and Son card showing a treelined borough street. West Chester has received official recognition as a Tree City because of its efforts to plant trees. Below is a postcard of South High Street displaying some of the commercial buildings, a church, and trolley tracks. It was sent on September 2, 1906, from "Grandmother" to California.

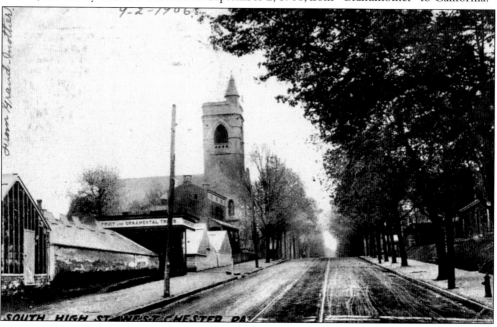

SOUTH HIGH ST. WEST CHESTER PA.

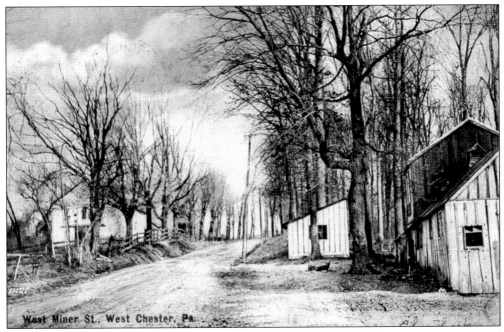

West Miner Street takes travelers to the historic Brandywine River. The above postcard, produced by S. J. Parker and Son, was mailed in 1907. Below is a scene along the West Chester and Coatesville trolley line. Several people appear at the top of the road, and a bridge over a stream is visible. Sent in 1908, this postcard notes a trip to Millersville to attend a commencement.

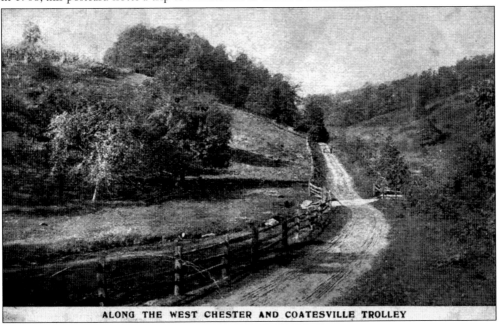

ALONG THE WEST CHESTER AND COATESVILLE TROLLEY

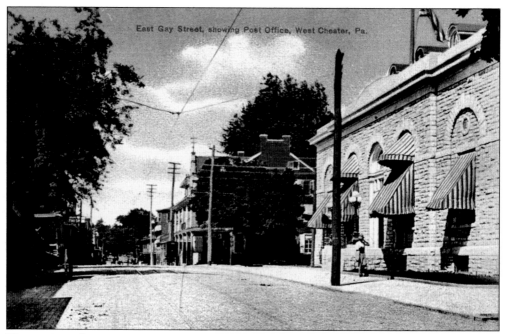

The section of East Gay Street shown above is the commercial district near Walnut Street. The West Chester Post Office is the building to the right with the red-striped awnings. The below postcard reveals the West Chester Penn Central rail depot in the mid-1970s. The use of the depot was, for the most part, discontinued about the time the postcard was produced.

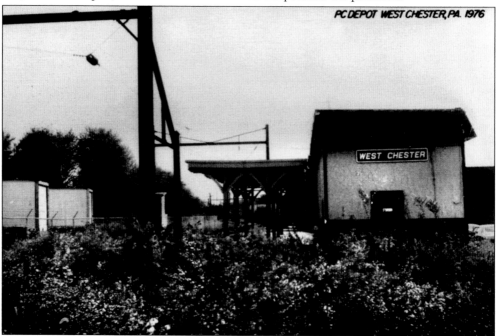

PC DEPOT WEST CHESTER, PA. 1976

WEST CHESTER

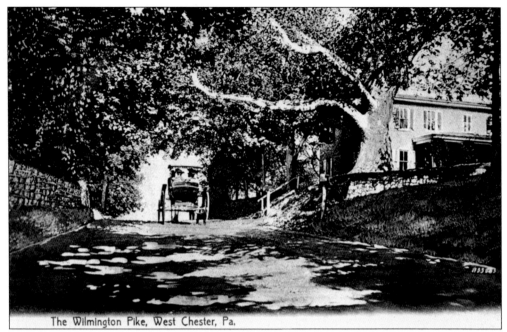

The Wilmington Pike, West Chester, Pa.

West Chester's central location in southeastern Pennsylvania was one of the many reasons for its founding and continued prosperity. One of the nearby major cities is Wilmington, Delaware. Today, Wilmington is about a half-hour drive south on Route 202, also known as the Wilmington Pike. These two postcards, both of that roadway, were issued by S. J. Parker and Son. The one below bears a postmark of 1909.

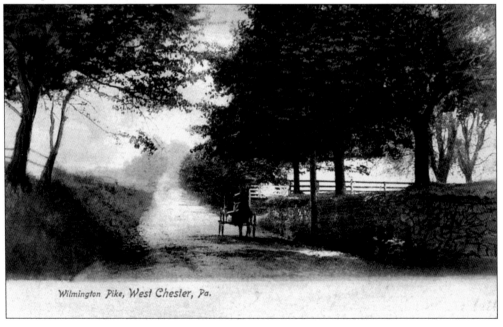

Wilmington Pike, West Chester, Pa.

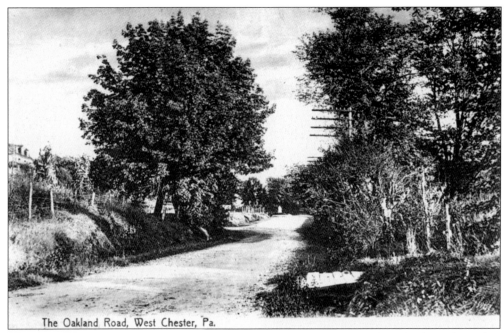

The Oakland Road, West Chester, Pa.

S. J. Parker and Son also issued two versions of the Oakland Road postcard. Both, shown here, date from the early part of the 20th century. Oakland Road is located near the Wilmington Pike, the subject on the previous page. Several homes can be seen along the rural road in these postcards, which were made in Germany for Parker.

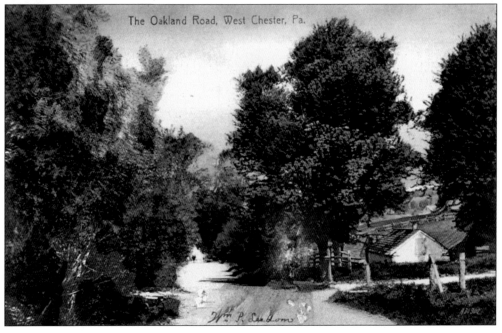

The Oakland Road, West Chester, Pa.

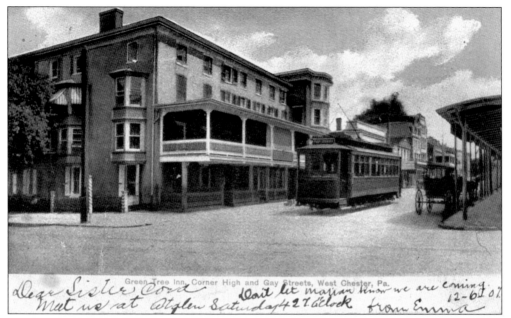

Dear Sister Cora Don't let Marian know we are coming. Met us at Atglen Saturday 4-27 O'clock from Emma 12-6-'07

Green Tree Inn, Corner High and Gay Streets, West Chester, Pa.

With the coming of the trolley and the automobile, the horse-drawn wagons began disappearing from the streets of West Chester. Above, a trolley appears at the corner of High and Gay Streets in front of the Green Tree Inn. Below is a section of Church Street near the high school. Both of the postcards were mailed in the early 1900s.

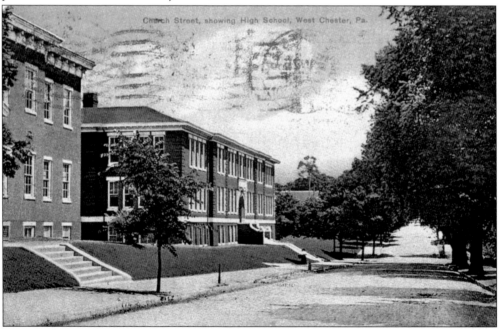

Church Street, showing High School, West Chester, Pa.

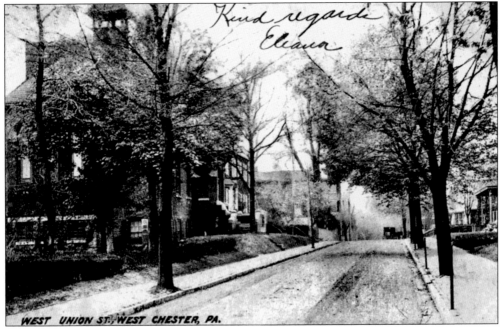

WEST UNION ST., WEST CHESTER, PA.

A horse-drawn buggy travels on West Union Street in the above card, while the card below, published by S. J. Parker and Son, reveals a view of "Chester road from West Chester and Philadelphia Trolley." Both were written to friends; the below card was signed, "Your chum."

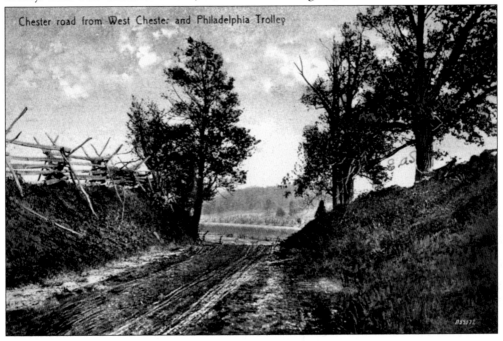

Chester road from West Chester and Philadelphia Trolley

Three

RELIGIOUS INSTITUTIONS

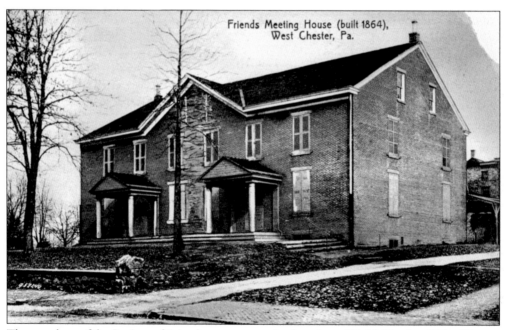

The members of the Society of Friends were among the founders of Turk's Head and West Chester. When the borough was formed in 1799, the Friends did not have a meetinghouse, and members attended one of the many other halls in the area. This S. J. Parker and Son card shows the Friends meetinghouse, built in 1864.

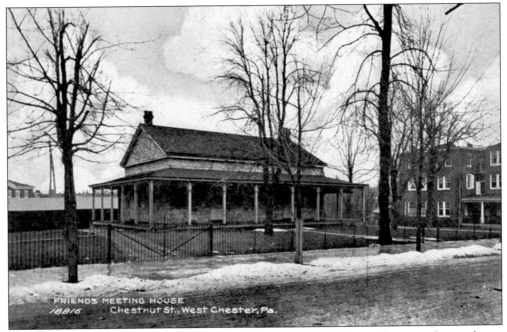

FRIENDS MEETING HOUSE
18816 Chestnut St., West Chester, Pa.

The Society of Friends split in 1827, with one faction erecting a meetinghouse at the northwest corner of Chestnut and Church Streets. A second meetinghouse was built 17 years later. The two groups later rejoined. The Chestnut Street building, seen above, was torn down in the 1960s. Below, children play in front of the Friends school and meetinghouse on High Street. One of the students runs to the left of the view, while the rest appear to be looking at the camera. The same field is used today.

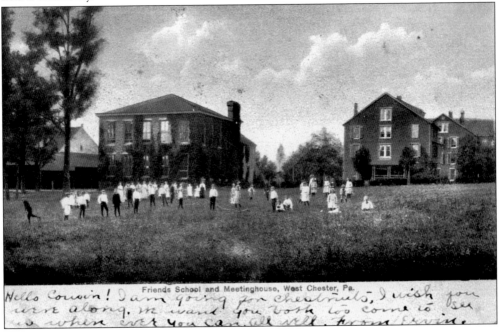

Friends School and Meetinghouse, West Chester, Pa.

Hello Cousin! I am going for chestnuts, I wish you were along. We want you both too come to see us when ever you can. All well. From Ervin.

The two groups of Friends in West Chester were involved in education and founded schools in the 1800s. A school is still run today from the High Street location. The postcard above shows the High Street meetinghouse, while the one below, by S. J. Parker and Son, depicts the "Friends Boarding Home, West Chester, Pa." The Society of Friends remains active in the community.

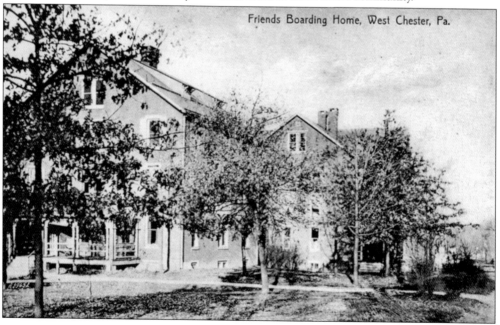

Friends Boarding Home, West Chester, Pa.

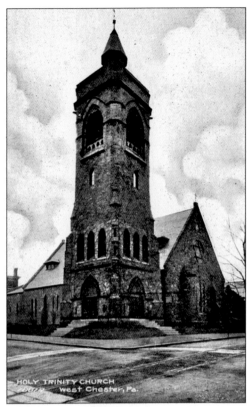

HOLY TRINITY CHURCH
west Chester, Pa.

One of the most distinctive church towers belongs to the Church of the Holy Trinity at High and Union Streets. Anthony Bolmar founded the church, with the first building constructed on West Gay Street between New and Darlington in 1838. The two postcards on this page depict the Union Street church.

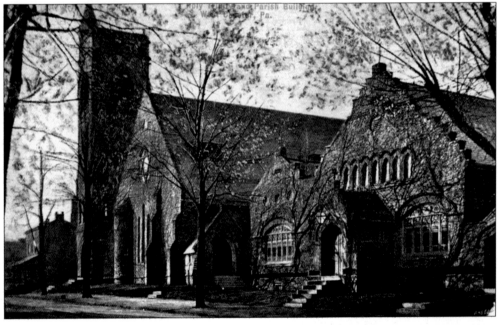

These postcards display slightly different angles of the Church of the Holy Trinity. The black-and-white card to the right bears a 1905 postmark, while the one below, produced in color, has a 1921 postmark. A parish building was constructed in 1882, and the tower was added six years later. A few years later, the building underwent additional construction.

Church of the Holy Trinity, West Chester, Pa.

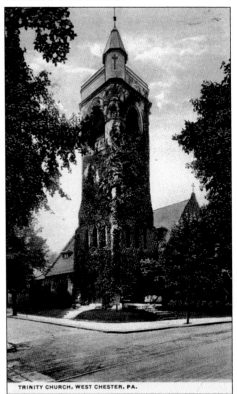

TRINITY CHURCH, WEST CHESTER, PA.

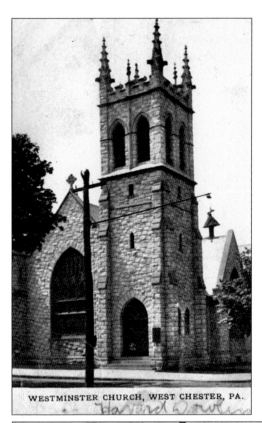

WESTMINSTER CHURCH, WEST CHESTER, PA.

The Westminster Presbyterian Church was created after the First Presbyterian Church had become overcrowded. These postcards show different views of the Westminster Church, located at Church and Barnard Streets. The church received its charter in 1893 and held its first service from the chapel in June 1900. More than 90 years later, the church moved out of the borough because it had outgrown the facility.

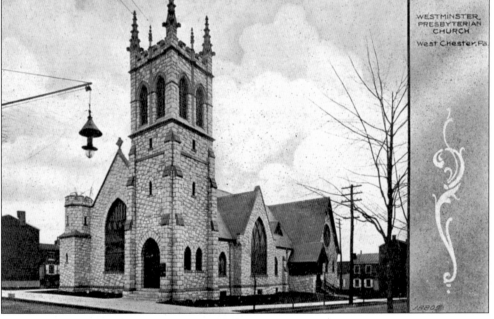

WESTMINSTER PRESBYTERIAN CHURCH West Chester, Pa

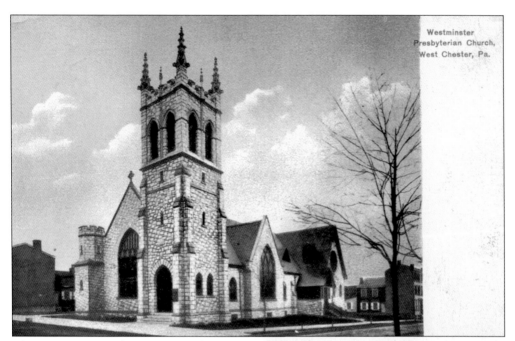

The Westminster Presbyterian Church is shown above with several of the surrounding residential buildings. St. Agnes Catholic Church on Gay Street, seen to the right, began in 1793 as Christ's Church. The original structure was demolished in 1852, and a new one was built that year. The present Gothic-style church dates to 1925.

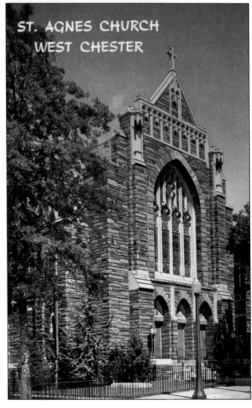

ST. AGNES CHURCH
WEST CHESTER

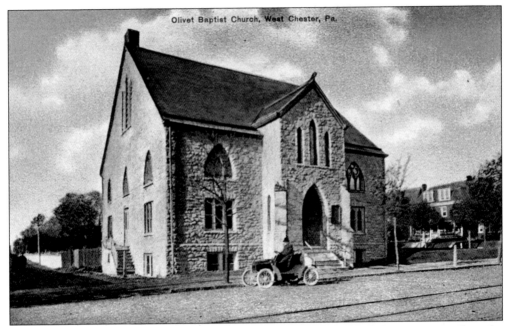

Olivet Baptist Church, West Chester, Pa.

Two similar views of the Olivet Baptist Church appear here. The church's roots stem from the formation of the Central Union Association of Baptist Churches in 1832. The first services were held at the courthouse. The church congregation split at various times, and the resulting Olivet Baptist Church was organized in 1897. In the above postcard, a car appears and the tree is bare of leaves.

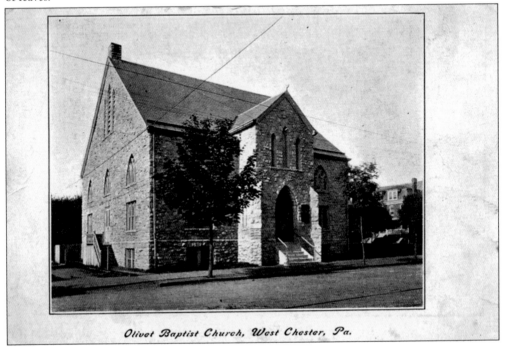

Olivet Baptist Church, West Chester, Pa.

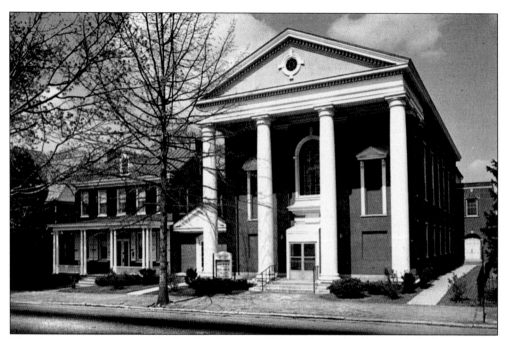

The above postcard shows the Baptist Church of West Chester on South High Street. Major changes to the building were made in 1930, and an annex was added in 1961. The First Baptist and the Olivet Baptist Churches merged in 1929. The first combined service was held on March 3, 1929. Below is a view of the First Presbyterian Church of West Chester, located on Miner Street.

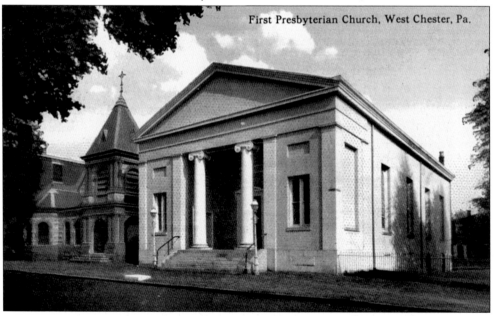

First Presbyterian Church, West Chester, Pa.

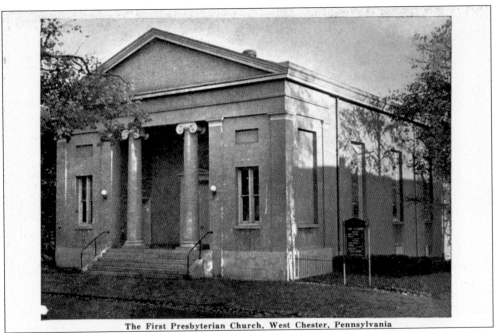

The First Presbyterian Church, West Chester, Pennsylvania

The cornerstone of the First Presbyterian Church was laid on July 3, 1832, and the first service, attended by 52 members, was held in January 1834. The two postcards on this page were "Natural-Finish" cards made by a Danville, Virginia, company. The church design was the first commission of Thomas U. Walter, known as the country's preeminent Greek Revival architect.

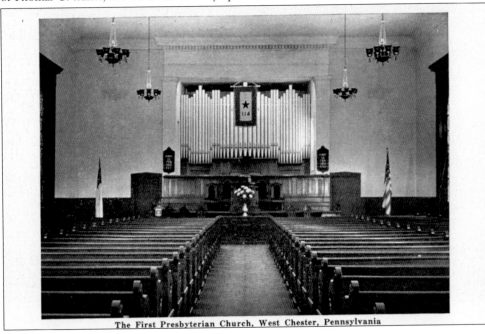

The First Presbyterian Church, West Chester, Pennsylvania

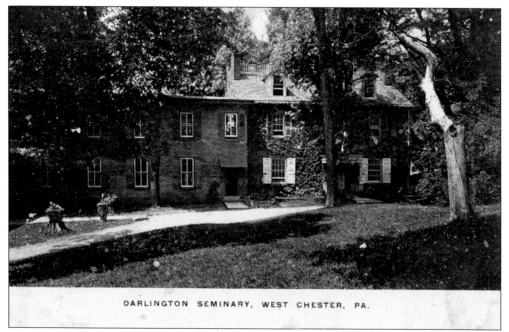

DARLINGTON SEMINARY, WEST CHESTER, PA.

The above postcard, picturing the Darlington Seminary in West Chester, was sent in 1908 from a boy named Raymond to his aunt in Kennett Square. It reads, "Dear Auntie, I'm feeling better now and can run and play and have a good time and feel good all of the time. Your little boy, Raymond." The below card depicts the Friends meetinghouse.

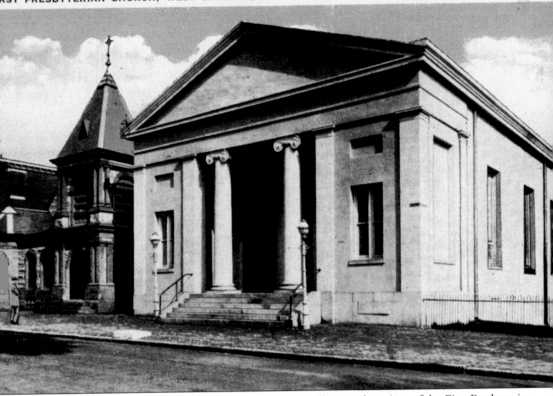

This postcard, published by P. F. Fath of West Chester, offers another view of the First Presbyterian Church. Located on Miner Street, the church is within easy walking distance of the borough's business district. It is noted for its music and choral groups.

Four

THE NORMAL SCHOOL

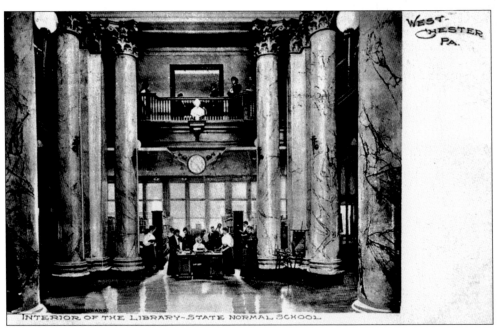

West Chester University has a long and proud history of educating students, not only from the borough but throughout the region. As with any institution of higher learning, the library is a vital part of the campus. In this interior view of the library, students hold books. Bearing a 1909 postmark, the card was sent to a woman living on Price Street in West Chester to inquire if she safely returned home.

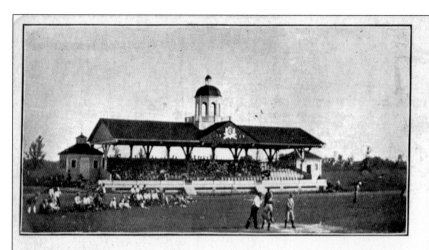

Wayne Field, West Chester, Pa. Henry's Souvenir Card.

Athletics has also been a source of pride for West Chester. On this page are two of the old fields used by the normal school's teams. The above card depicts Wayne Field, while the one below shows the old John A. Farrell Memorial Stadium. Baseball was always a town favorite. On April 19, 1880, the *Daily Local News* reported that the normal school had defeated the Worrall's school team.

John A. Farrell Memorial Stadium, West Chester, Pennsylvania

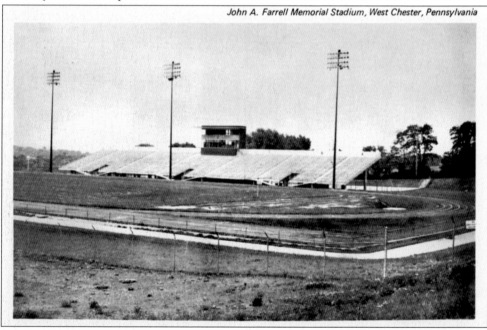

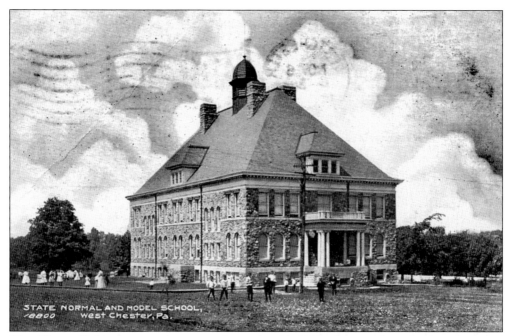

West Chester University traces its roots to September 28, 1811, when a group of interested citizens, including Dr. William Darlington, sought to establish an educational institution. West Chester Academy was incorporated in March 1812. Above, students loiter on the school's lawn—women to the left and men to the right—in a card with a 1908 postmark. Below is a view of Recitation Hall.

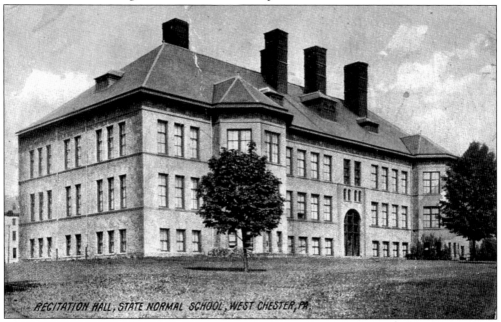

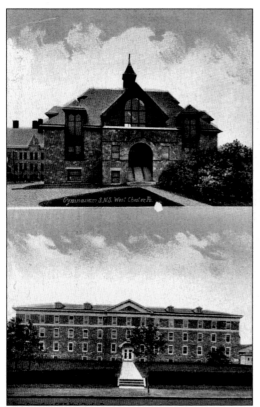

The postcard to the left is unusual in that it contains a double image of the normal school: the gymnasium and the boys' dormitory. The below postcard carries a 1906 postmark and shows the library with trees blocking a portion of the view.

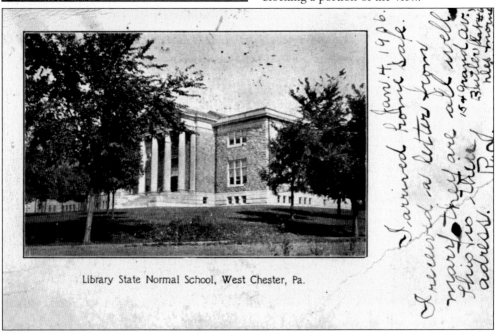

Library State Normal School, West Chester, Pa.

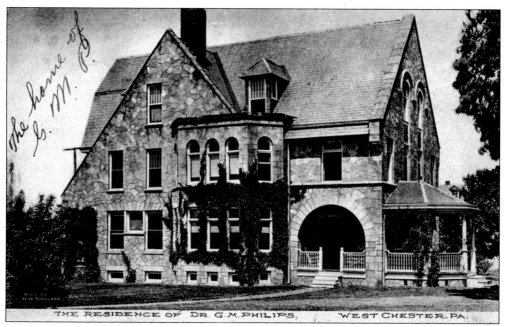

THE RESIDENCE OF DR. G.M.PHILIPS, WEST CHESTER, PA.

The residence of Dr. G. M. Philips is depicted above. Postmarked 1908, the card delivers a message concerning guests at an upcoming commencement. In 1906, the below postcard was used as a birthday greeting to a Honey Brook woman. It reads, "May your birthday be like a clear sky."

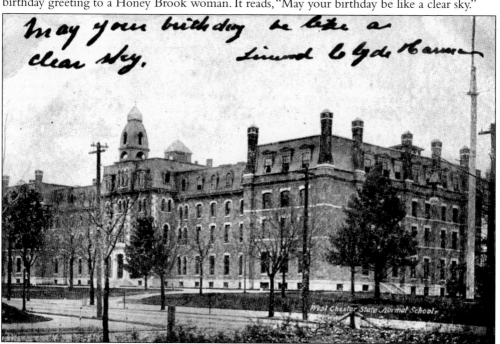

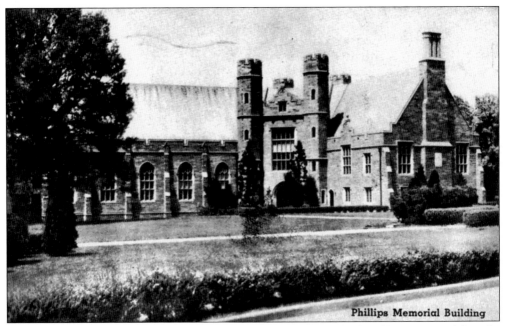

Phillips Memorial Building

The above postcard shows the Philips Memorial Building, mistakenly adding a second *l* to the Philips name. Construction of the building began in 1926. A plaque on the campus states, "George Morris Philips Principal and Upbuilder of the School 1881–1920." The below card, showing Recitation Hall, carries a 1911 postmark.

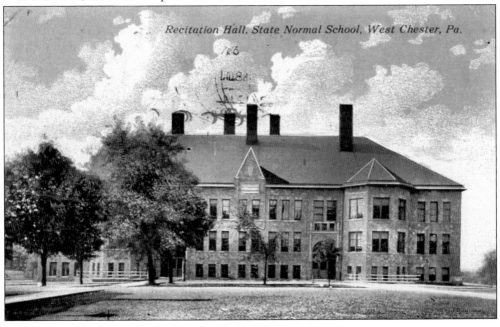

Recitation Hall, State Normal School, West Chester, Pa.

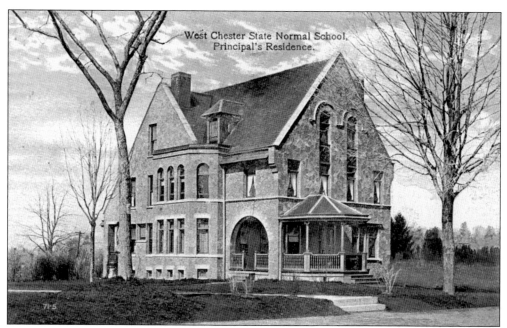

West Chester State Normal School,
Principal's Residence.

Two different views of the same building are on this page. The above card, with a 1920 postmark, describes the building as the "Principal's Residence." Below, the structure is called the "President's Home." The below card was sent in 1915 from one sister to another to relay family information.

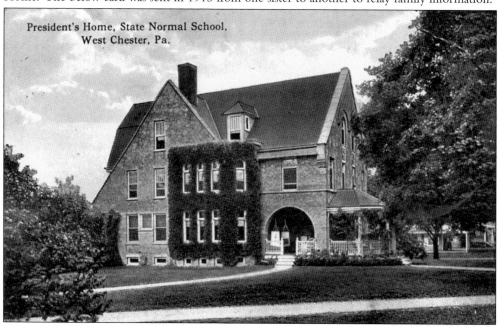

President's Home, State Normal School,
West Chester, Pa.

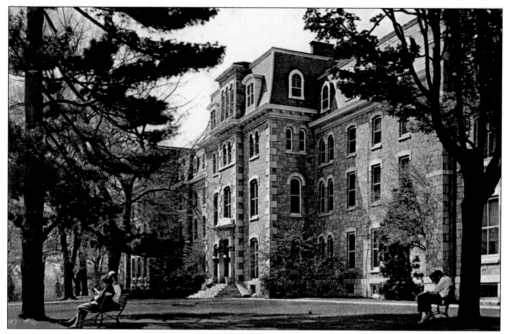

When the above postcard was produced, the "Main Building" doubled as the "Woman's Dormitory." The building was constructed in 1870 of local serpentine stone and is now known as "Old Main." The below card is depicts Wayne Hall, a men's dormitory when the school was West Chester State Teachers' College. The building also used serpentine stone and was named in honor of local Revolutionary War hero Anthony Wayne.

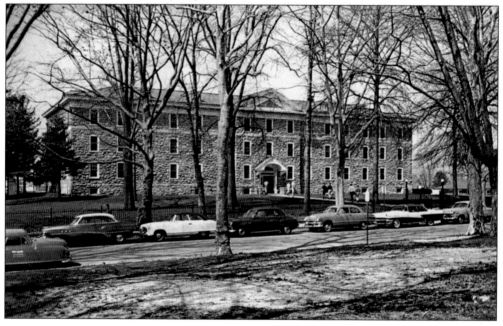

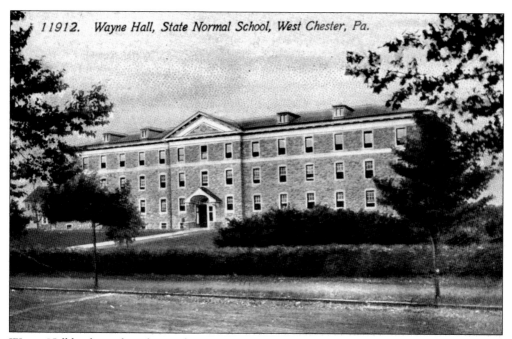

11912. *Wayne Hall, State Normal School, West Chester, Pa.*

Wayne Hall has been the subject of a number of different postcard series. Above is a card published by the Acmegraph Company of Chicago. In the card below, a student tells her friend that she has no classes scheduled that September day and plans to go to the county fair. She does mention that she has classes every period the next day.

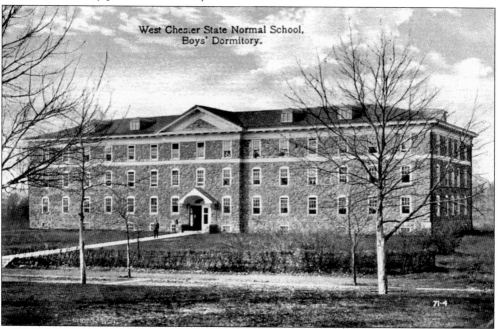

West Chester State Normal School,
Boys' Dormitory.

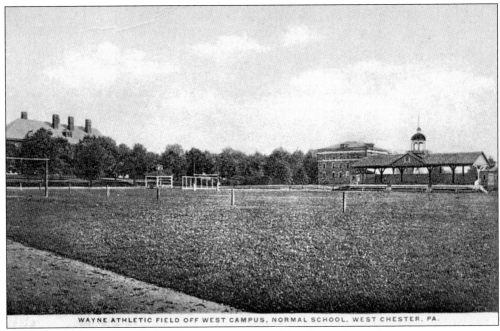

WAYNE ATHLETIC FIELD OFF WEST CAMPUS, NORMAL SCHOOL, WEST CHESTER, PA.

The playing fields of West Chester were remembered by the student who wrote a message on the back of the above postcard of "Wayne Athletic Field off West Campus, Normal School, West Chester, Pa." The student wrote, "It was here we enjoyed victories and suffered defeat." The below card shows a playing field in back of the main educational buildings.

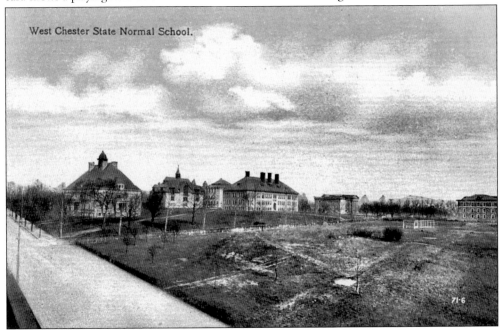

West Chester State Normal School.

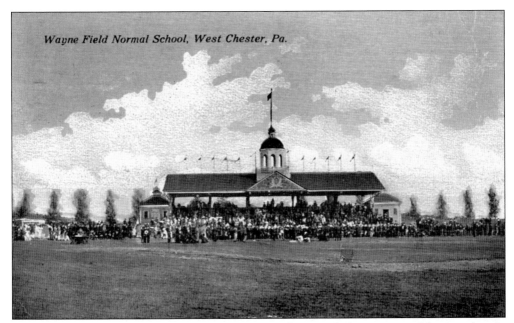

Wayne Field Normal School, West Chester, Pa.

The "Wayne Field Normal School, West Chester, Pa." postcard above was used by a student in 1913 to entice a former high school friend, Laura, to write to him while he attended West Chester Normal School. He closed by saying, "Would love to hear from you once in a while if you're not too busy." The postcard below, sporting the school's seal, was also mailed in 1913.

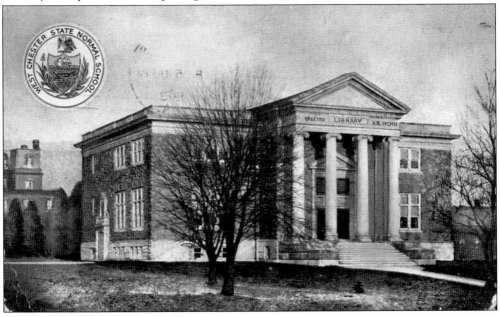

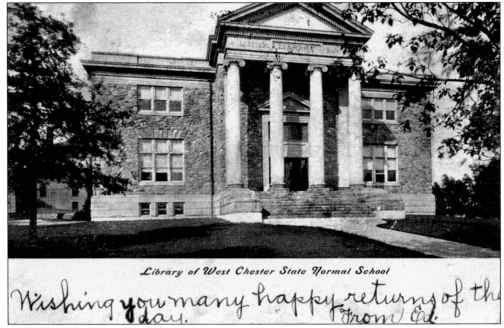

Library of West Chester State Normal School

Wishing you many happy returns of the day. From Ed.

The above postcard bears a note from another male West Chester student in 1907 to a woman friend in Barneston, Chester County. The less personal message reads, "Wishing you many happy returns of the day. From Ed." Both views on this page are of the school's library. The above card was produced in West Chester by A. Henry of North Church Street.

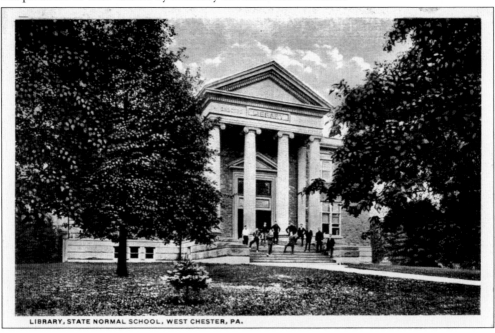

LIBRARY, STATE NORMAL SCHOOL, WEST CHESTER, PA.

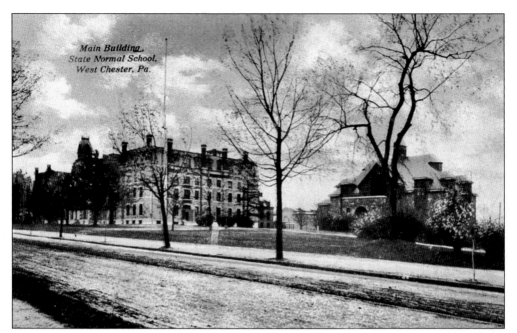

The West Chester campus includes a lot of open space for students to walk on warm spring and fall days. Over the years, the campus has expanded south, away from the center of town. Both educational and residential buildings have been added. Two views of the campus are shown here. The below postcard is designated "Private Mailing Card—Authorized by Act of Congress May 19, 1898."

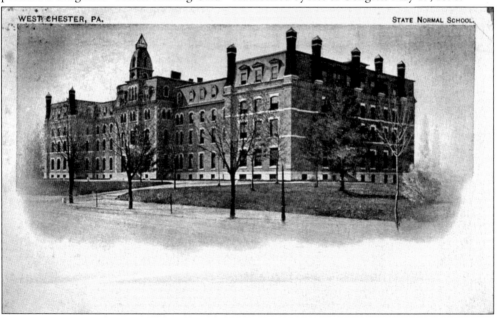

State Normal School, West Chester, Pa.

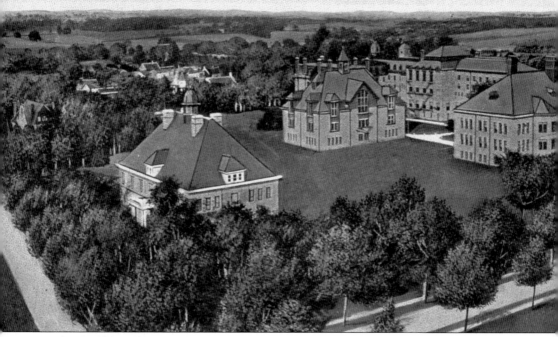

The double-width postcard on these two pages depicts the West Chester Normal School campus in the early 1900s. The postmark is covered by two 1¢ stamps, so the date of sending is not known. The card was produced in Philadelphia and was sent by a student, Edna, to her grandmother Mary

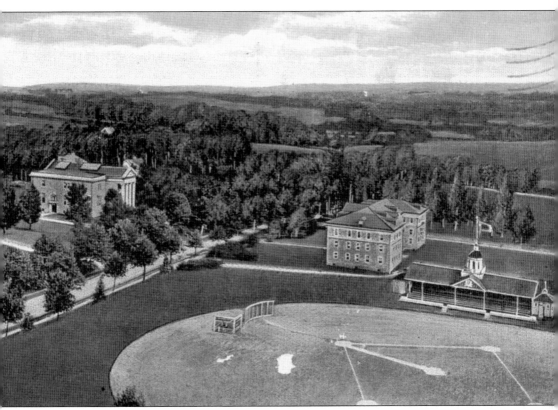

H. Moyer of Blooming Glen. The message reads, "In the midst of hard studying this evening. I happened to think of you, so, am sending you a picture of the school. How are you? I'm enjoying West Chester [*word unclear*] greatly, Edna." The card was sent in care of Dr. H. C. Moyer.

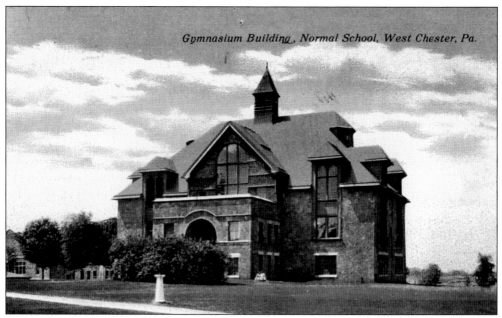

Gymnasium Building, Normal School, West Chester, Pa.

Postcards were used as notes to worried parents over the years, as evidenced by the above postcard from daughter to mother in 1910. It says, in part, "I was weighed and guess how much I weigh. 143 lbs. Mrs. Yerkes thought I was very thin when I came but I am picking up rapidly. I am well and study hard. I like it very much here better than last year." Both cards on this page are of the gymnasium.

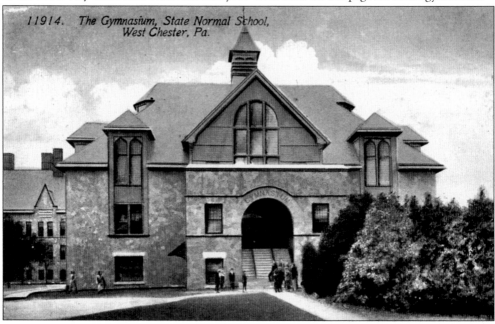

11914. The Gymnasium, State Normal School, West Chester, Pa.

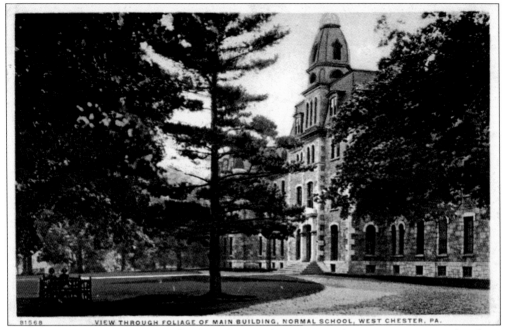

Through the years, West Chester has been known for its outstanding music program. The above postcard, entitled "View through foliage of Main Building, Normal School, West Chester, Pa," was mailed by a student taking a summer music course in 1922. The student tells a friend the campus is "only 25 miles from Philadelphia. It is a beautiful college and city and I sure do enjoy its course in music." The below postcard is a bleaker view of the campus sent during the winter of 1909.

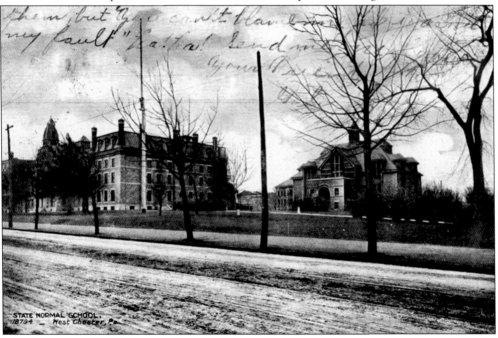

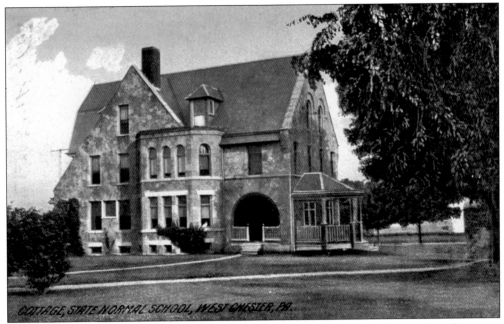

The above postcard of the "Cottage, State Normal School" was to be sent internationally as part of a Christmas message, but no address was printed. It is signed, "Your friend from the States." West Chester can have long, cold winters with snow or relatively mild ones. In the below postcard mailed in January, a student writes, "The indications are that winter will be very short-lived at least in West Chester."

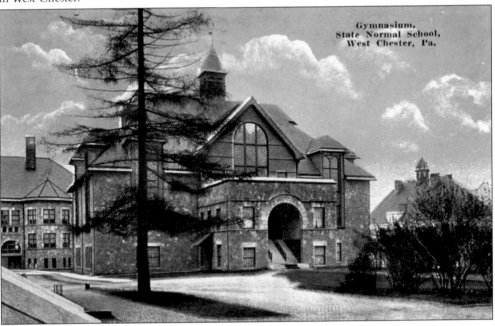

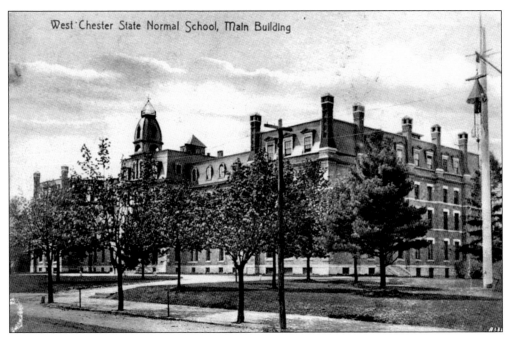

West Chester State Normal School, Main Building

The S. J. Parker and Son collection included views of the West Chester Normal School. The Parker postcard above was sent in 1907. These two cards show slightly different views of the main building. The one below, a "Henry's Souvenir Card," was mailed in 1906 to Sr. Margaret Gabel at German Hospital in Philadelphia.

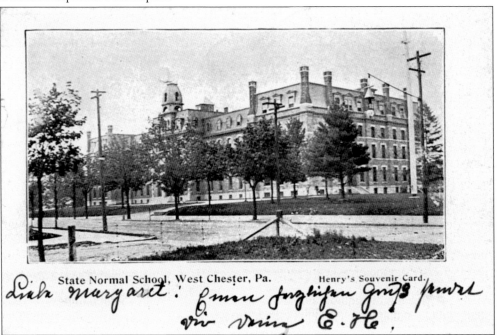

State Normal School, West Chester, Pa. Henry's Souvenir Card.

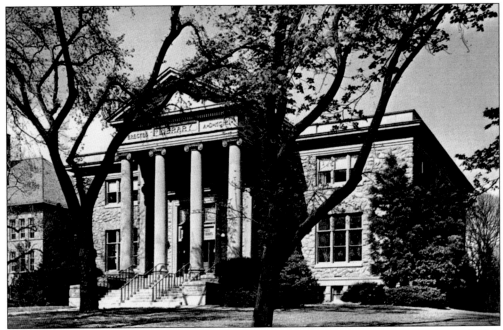

These views of the "West Chester State Teachers College." campus were taken in the mid-20th century, judging by the appearance of the cars below. This card shows the "Main Dormitory—Girls Dormitory," built of local serpentine stone from the plans of Addison Hutton in 1870. The Francis Harvey Green Library, pictured above, was constructed in 1902 and remodeled in 1938–1941.

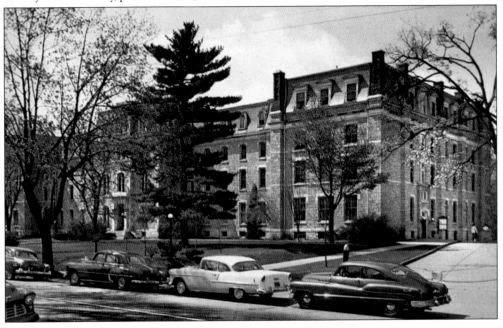

Five

COMMERCE

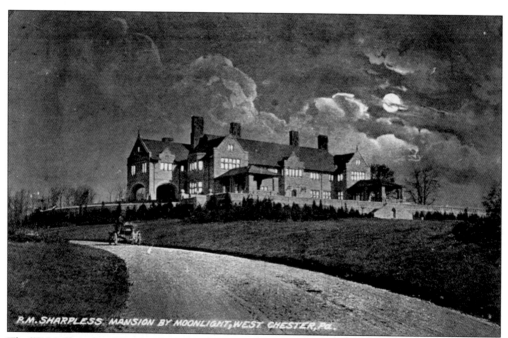

The "P. M. Sharpless Mansion by Moonlight, West Chester, Pa." postcard is one of many connected with the Sharples Cream Separator Company and the Sharples family. The family name was misspelled here, even though the card was produced by a West Chester company. Other cards in this section also give misinformation. Over the years, West Chester has been home to many different businesses with national reputations.

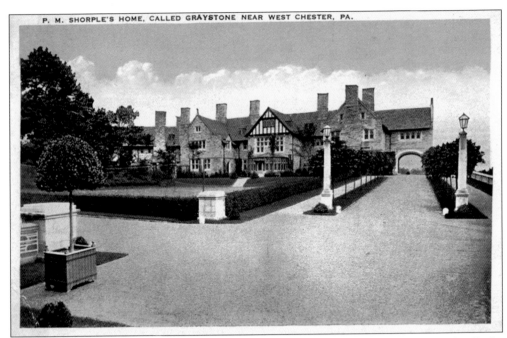

The Sharples family home, Greystone, was known for its gardens. The above postcard calls the family "Shorple" and shows a portion of the large mansion. Below, a portion of the "Summer Garden, Green Hill, near West Chester" is shown. The home is located near the northeast section of the borough of West Chester.

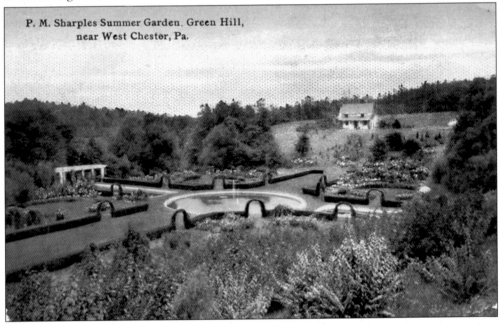

The Sharples Cream Separator Company produced a number of collectible postcards of its product during the early 1900s. The card to the right states that the Sharples separator "earns hundreds of dollars in cream saved over every other separator. Because it is the only separator that skims clean at widely varying speeds; delivers cream of unchanging thickness at all speeds; has simple tubular bowl, no discs to clean; has knee-low supply tank; has automatic splash oiling system—no oil holes or muss."

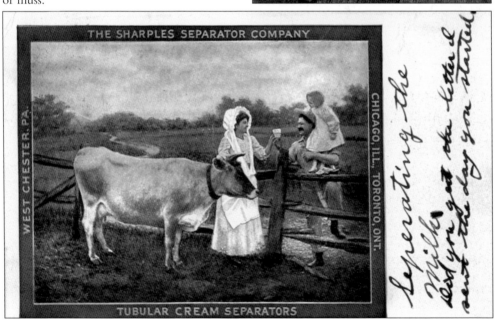

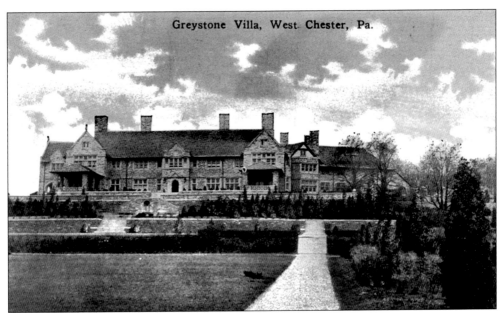

Greystone Villa, West Chester, Pa.

The Sharples cream separator was sold throughout the nation, even by the John Deere Company in the Midwest, and was a huge financial success. Two views of the family home—called a villa, mansion, and hall in various postcards—are shown here. Philip M. Sharples was born in 1857 and attended the West Chester Normal School. He went to Sweden in 1885 to meet the founder of a cream separator company, and the two became business partners.

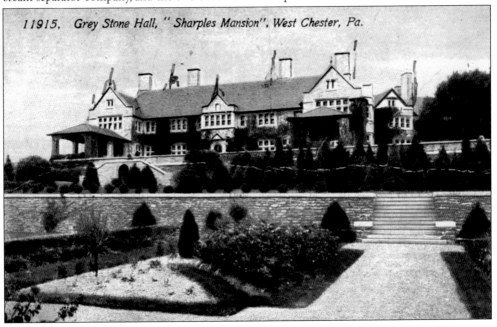

11915. Grey Stone Hall, "Sharples Mansion", West Chester, Pa.

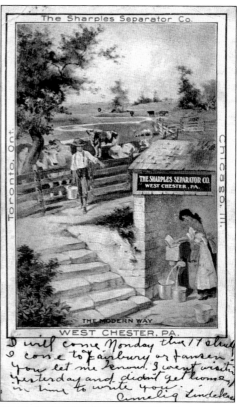

Two more Sharples Cream Separator Company postcards appear on this page. The card to the right bears a postmark of 1908. In 1915, Philip Sharples's son made improvements to the cream separator by adding a centrifugal force technique, thus forming the Sharples Corporation. The two companies became business competitors. An oil shortage during World War I and the Great Depression doomed the Sharples Corporation.

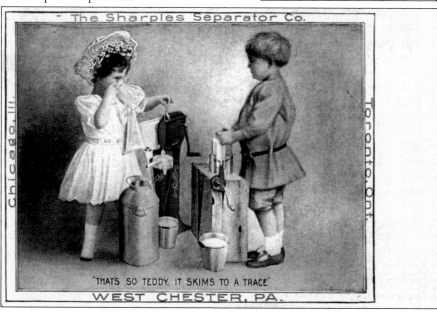

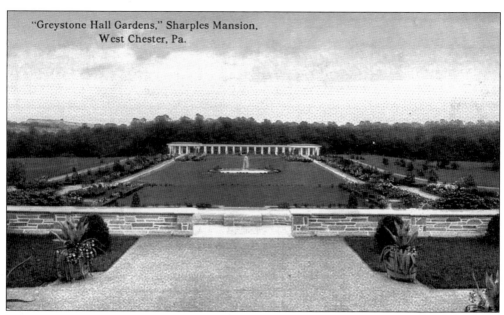

"Greystone Hall Gardens," Sharples Mansion, West Chester, Pa.

At one point, the Philip M. Sharples's company employed 1,000 workers. In the 1890s, a plant was built in West Chester, and the building is now used as a luxury apartment complex. Philip M. Sharples was a community leader and once the president of the Farmers and Merchants Trust Company. He died on April 13, 1944. These two different postcards of the Sharples home were produced by the same company.

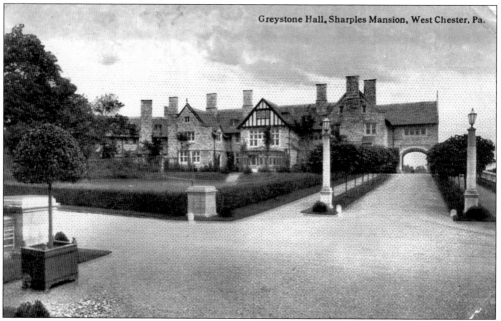

Greystone Hall, Sharples Mansion, West Chester, Pa.

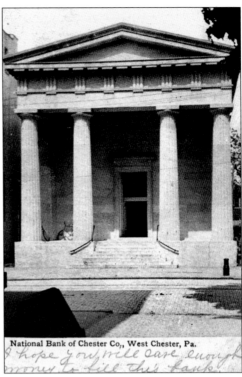

West Chester has been a banking and financial center for the region since the town's founding. The Bank of Chester County opened for business on November 11, 1814. Architect Thomas U. Walter was selected to design the new building, shown to the right. The bank abandoned its state charter and became national in 1864, after the National Banking Act of 1863 was enacted. The financial crisis sparked by the Civil War was a factor in forming the First National Bank of West Chester, shown below.

National Bank of Chester Co,, West Chester, Pa.

I hope you will save enough money to fill this bank.

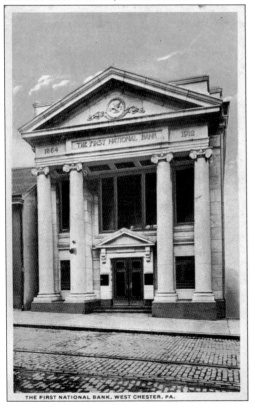

THE FIRST NATIONAL BANK, WEST CHESTER, PA.

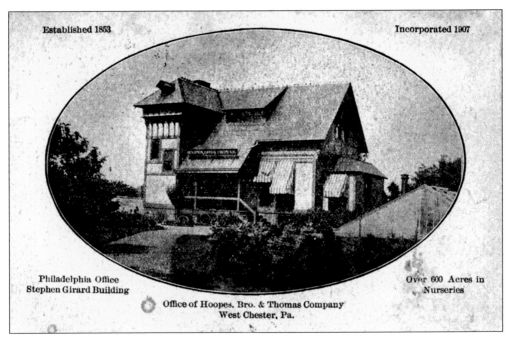

Established 1853 Incorporated 1907

Philadelphia Office Over 600 Acres in
Stephen Girard Building Nurseries

Office of Hoopes, Bro. & Thomas Company
West Chester, Pa.

One business lasting a number of years in West Chester was the Hoopes Brothers and Thomas Company. The company, which included more than "600 acres in nurseries," was established in 1853. Postmarked 1910, the above postcard shows the West Chester office. West Chester also had a strong transportation system helping businesses and commuters. Below is the interior of a car on the Philadelphia and West Chester Electric Railway.

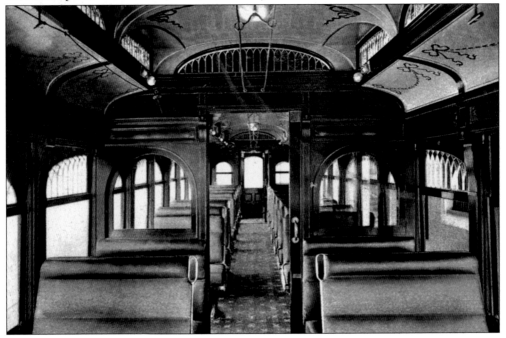

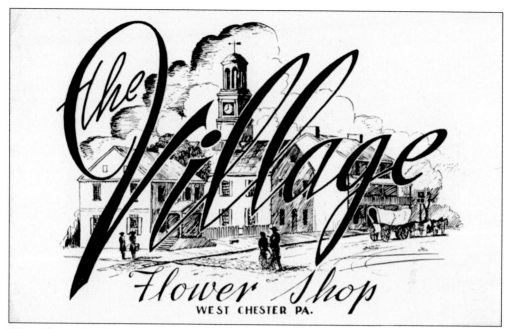

WEST CHESTER PA.

West Chester has had its share of flower shops and greenhouses over the years. In the above postcard, the Village Flower Shop is advertised. The business was situated on Market Street, across from the courthouse, in a building constructed in 1846. The postcard below shows the interior of Kift's Greenhouses, located at 320 South High Street. At the time the postcard was published, the proprietor was David R. Trapp.

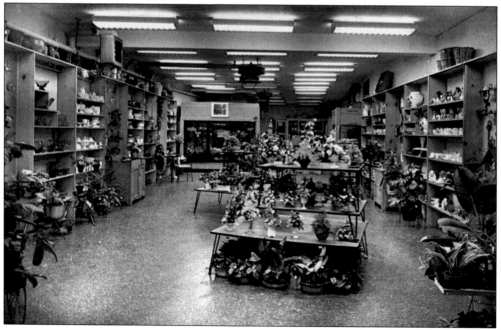

The Hickman Memorial Home, pictured above, was founded in 1891. The building was dedicated to the memory of Samuel G. Hickman and his brother Nathaniel G. Hickman. Today, the Hickman is a not-for-profit residential and assisted-living community. The card below shows the interior of the Quaker Restaurant at 124 West Gay Street. Today, the West Chester business district contains a thriving restaurant community.

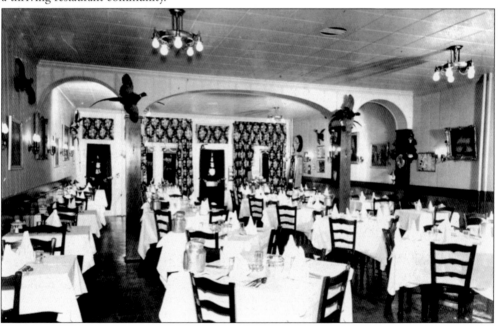

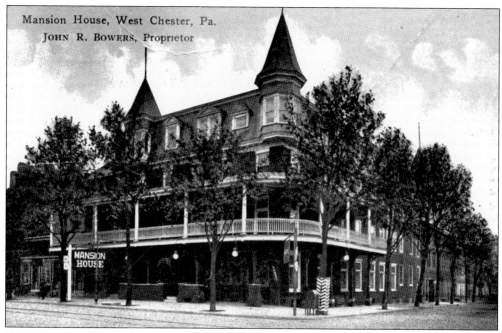

Mansion House, West Chester, Pa.
JOHN R. BOWERS, Proprietor

Taverns, inns, and hotels have been a part of West Chester since the village was first named Turk's Head after a tavern. The two images on this page show the old Mansion House in West Chester. A number of different versions of the postcard have been issued. The above card was used when John R. Bowers was proprietor, and the one below when James C. Millhizer was proprietor.

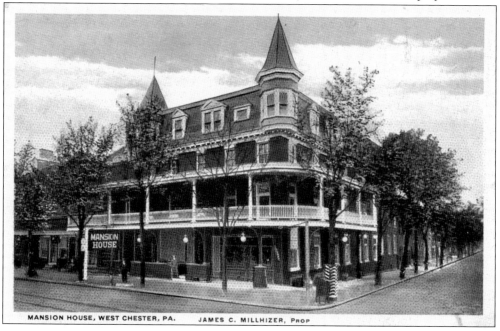

MANSION HOUSE, WEST CHESTER, PA. JAMES C. MILLHIZER, PROP

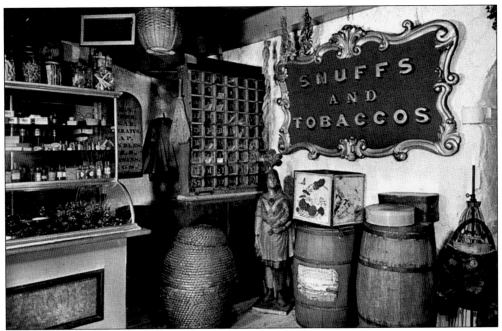

Just south of the borough line is a West Chester landmark, Baldwin's Book Barn, where thousands and thousands of old and rare books are housed in a multistory building. At one time, the Book Barn was known as the Old Country Store Museum. These postcards show two interior views; the above card advertises a public auction.

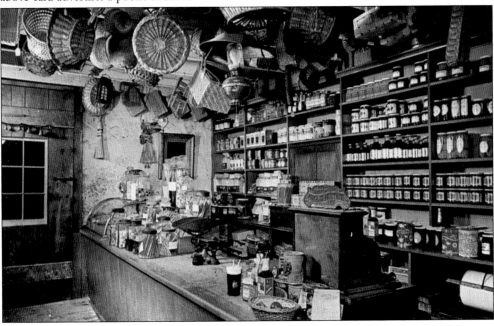

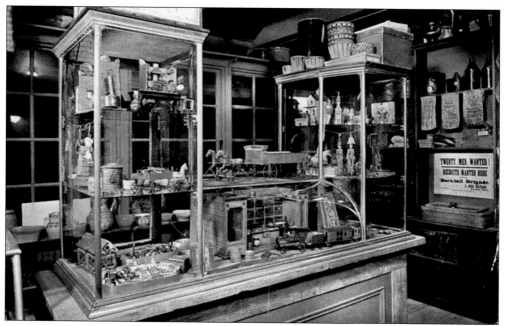

The interior of the Old Country Store Museum is seen here. The postcard above shows an old toy display. In addition to numerous old toys, including a horse-drawn wagon, a Civil War recruitment poster hangs on the wall. A checkers game is set, awaiting players, in the card below.

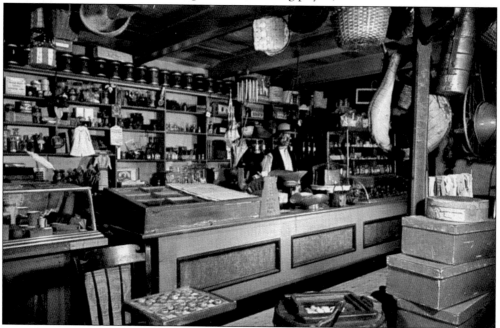

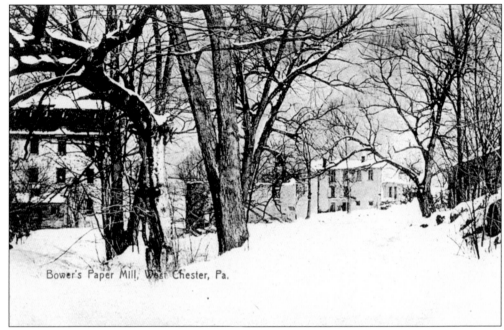

Bower's Paper Mill, West Chester, Pa.

The postcards on this page, produced by S. J. Parker and Son, are views of the old "Bower's Paper Mill, West Chester, Pa." The mill was located on the Brandywine River, outside of the borough. Showing the "ruins of laborer's homes," the postcard below bears a message that reads, "This ought to look home like to you."

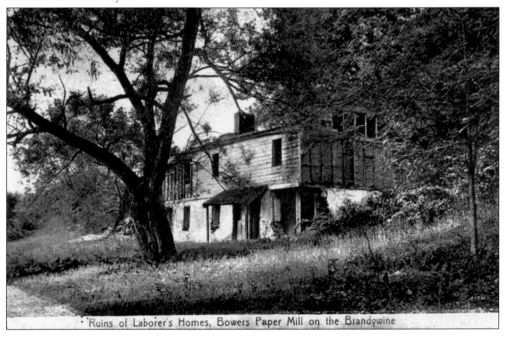

Ruins of Laborer's Homes, Bowers Paper Mill on the Brandywine

Six

PARKS

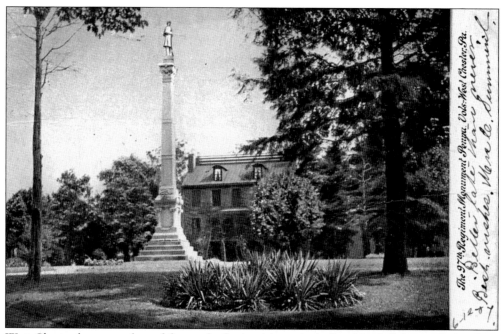

West Chester has a number of fine parks for its citizens, including Marshall Square Park, where the monument to the Civil War soldiers of the 97th Pennsylvania Volunteer Regiment is located. Col. Henry R. Guss commanded the regiment, and Civil War hero Galusha Pennypacker originally captained Company A. Many of the regiment's soldiers were recruited in the West Chester area.

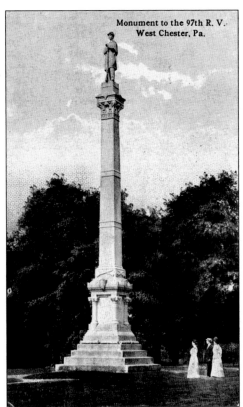

Monument to the 97th R. V.
West Chester, Pa.

Additional views of the monument to the
97th Pennsylvania Volunteer Regiment are
shown on this page. The 97th Regiment fought
in a number of famous battles during the
Civil War, including Gettysburg. West Chester
dentist Isaiah Price helped to recruit members
throughout Chester County. The regiment
also spent time fighting in Florida and other
southern states.

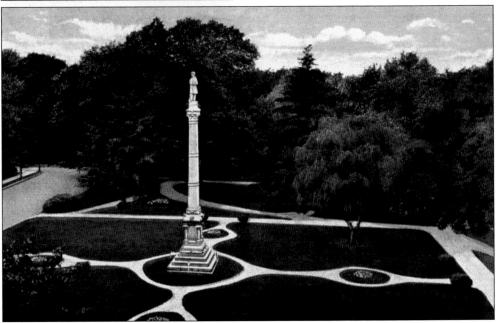

Marshall Square -- West Chester, Pa.

Many happy returns, Florence.

Marshall Square Park contains more than just the monument to the 97th Pennsylvania Volunteer Regiment. Today, it has open land where residents can walk, picnic, or play. The above postcard bears a 1906 postmark. The below card, produced by S. J. Parker and Son, shows one of the many nice homes surrounding the park.

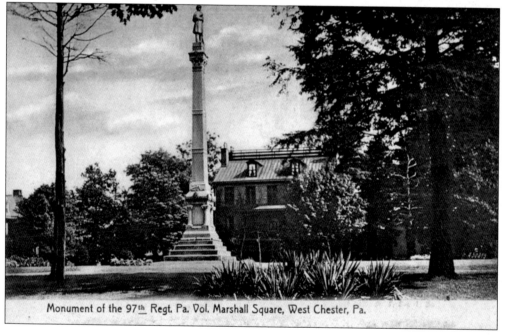

Monument of the 97th Regt. Pa. Vol. Marshall Square, West Chester, Pa.

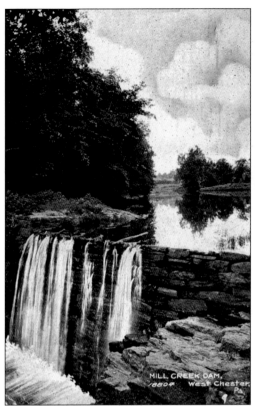

MILL CREEK DAM.
1880? West Chester, Pa.

Some published postcards indicate West Chester as the scene, but as with these two, the actual locations are just outside the town's borders. The card to the left, used for a birthday message, shows Mill Creek Dam, while the one below depicts a fox hunt at the Brandywine Meadow Farm.

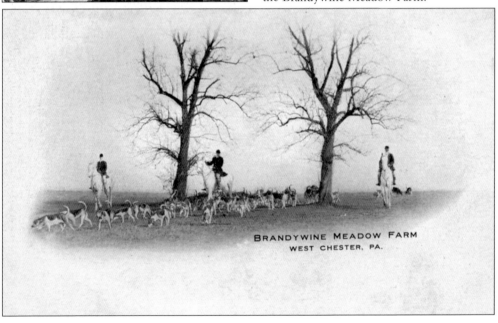

BRANDYWINE MEADOW FARM
WEST CHESTER, PA.

General View in Park showing Summer House,
West Chester, Pa.

One of the larger parks in West Chester is Everhart in the western section of the borough. These two postcards show how trees once dominated the park even more than today. The above card was sent in 1911 from one brother in Downingtown to another in Honey Brook, reminding him of a scheduled visit. The below card was published by S. J. Parker and Son.

Everhart Park, West Chester, Pa

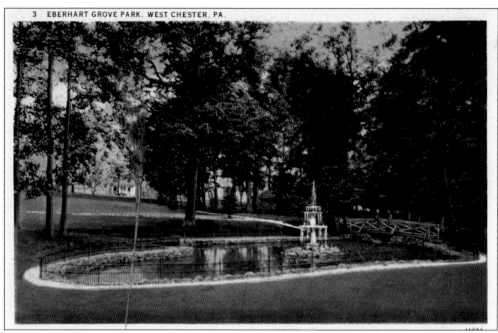

These two Everhart Park views are similar but not identical. The captions of both postcards are incorrect. Above, the scene is titled "Eberhart Grove Park, West Chester, Pa.," while below it is called "Evert park, West Chester, Pa." Neither postcard was mailed, but both were produced about the same time, in the early 1900s.

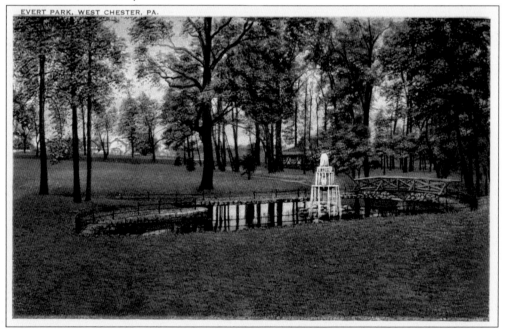

EVERT PARK, WEST CHESTER, PA.

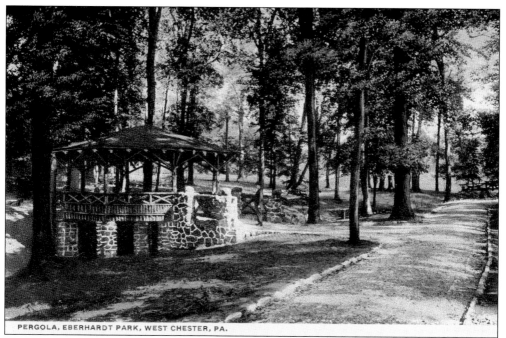

The above postcard shows the "Pergola, Eberhardt Park, West Chester, Pa.," continuing the misidentification of the park. Today, the park is used for music concerts and art shows. Below, in a postcard from Henry's Souvenir Card collection, is the Everhart Fountain, which at the time was located on West Market Street in the center of the West Chester business district.

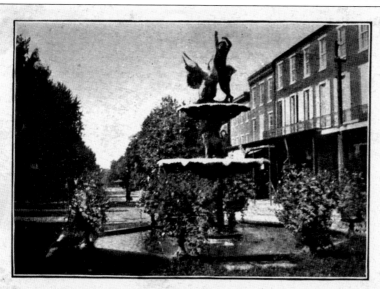

Everhart Fountain, W. Market St., West Chester, Pa. Henry's Souvenir Card.

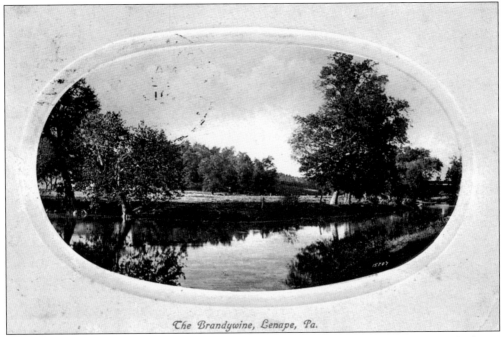

The Brandywine, Lenape, Pa.

West Chester residents seeking open spaces, parks, and recreation are not confined to the limits of the borough. The Brandywine River, flowing just to the west, has offered many recreational enjoyment opportunities over the years. These two S. J. Parker and Son postcards depict the Lenape area. The one above, postmarked 1913, shows the Brandywine as it still appears, and the one below, postmarked August 11, 1911, shows the old bath houses.

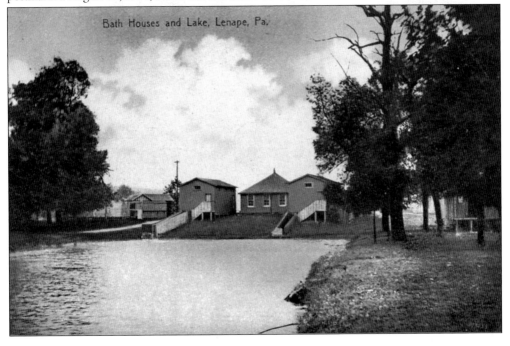

Bath Houses and Lake, Lenape, Pa.

Seven

PEOPLE AND PLACES

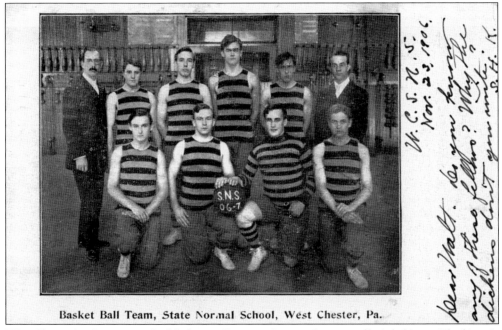

Basket Ball Team, State Normal School, West Chester, Pa.

West Chester has been a wonderful place to live over the years because of its inhabitants. The historic buildings, fine architecture, and beautiful parks all add to the allure, but the residents are essential elements of the town. The postcard on this page bears a 1906 postmark and shows the normal school's basketball team. The basketball indicates the team played during the 1906–1907 season.

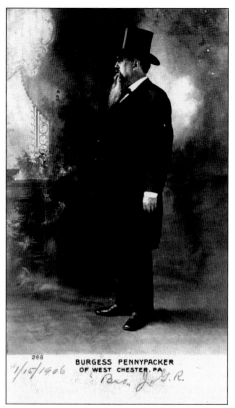

268
1/15/1906
Bro. Jo. T. R.
BURGESS PENNYPACKER
OF WEST CHESTER, PA.

Political leaders are important in any community. For years, West Chester was governed by those holding the position of burgess. To the left is one such burgess, Charles Pennypacker. A lawyer, Pennypacker served in office from 1903 until 1906. The postcard has a January 1906 postmark. Pictured below is former congressman Paul B. Dague, who had an office at 3 North Church Street. The postcard states that the office was open six days a week with a staff member available to help residents with problems.

SHAFER HAS NO STRINGS ON CADMUS

FRED T. CADMUS, III

DEMOCRATIC CANDIDATE

STATE SENATE - CHESTER COUNTY

The politician pictured to the right is Fred T. Cadmus III, who lost his race for Pennsylvania Senate. Cadmus was known as the "Country Lawyer," and besides practicing law, he operated a popular restaurant in West Chester called the Country Lawyer. The postcard below was mailed in West Chester on December 11, 1907. It shows a group of young men, including Charles Pennypacker (back row, far left).

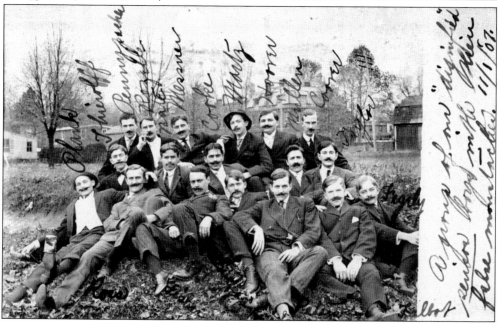

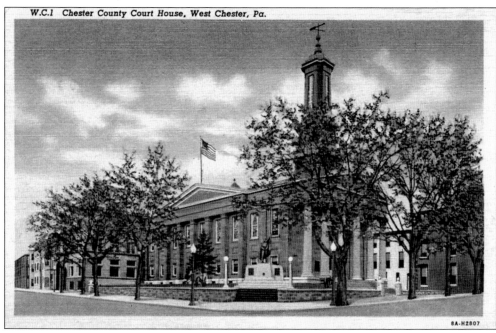

W.C.1 Chester County Court House, West Chester, Pa.

8A-H2807

Many different series of postcards involving West Chester have been produced over the years by a number of different companies and individuals. One set of eight postcards was developed, printed, and distributed in the 1940s by Lynn W. Boyer Jr. of Wildwood, New Jersey. The Chester County Courthouse appears above, and the Educational Building at West Chester State Teachers' College is below.

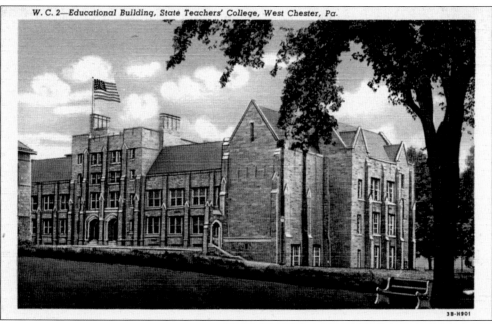

W. C. 2—Educational Building, State Teachers' College, West Chester, Pa.

3B-H901

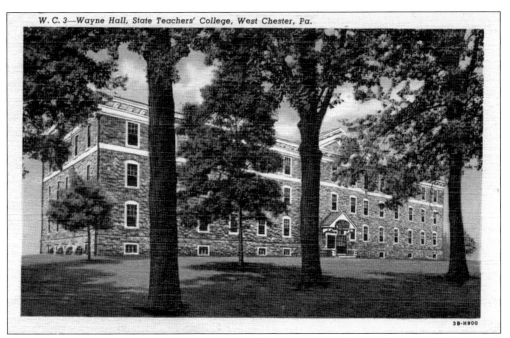

W. C. 3—Wayne Hall, State Teachers' College, West Chester, Pa.

3B-H900

The Boyer series is designated by "W. C.," followed by the series number in the upper left side of the cards. Two more views of the teachers' college are shown on this page. Above is Wayne Hall, while below is the main dormitory. "This has been my headquarters for the past two weeks—last lap to go, finish on Friday. It's been very nice," writes the sender of the below postcard.

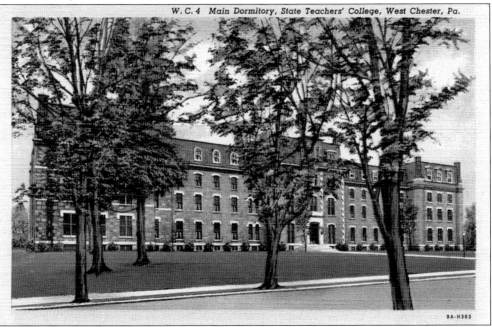

W. C. 4 Main Dormitory, State Teachers' College, West Chester, Pa.

9A-H383

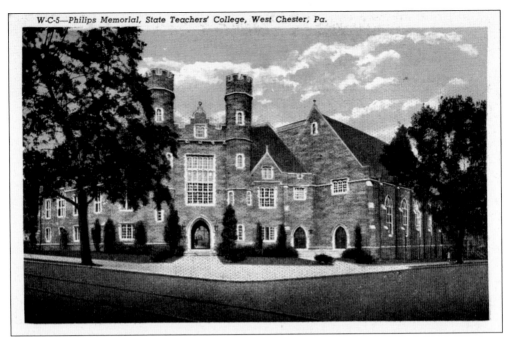

W-C-5—Philips Memorial, State Teachers' College, West Chester, Pa.

The fifth postcard in the Boyer series depicts the Philips Memorial on the teachers' college campus, shown above. Below, the seventh postcard of the series shows the Chester County Hospital. Several collectors have reported never seeing the sixth card of the series, and it is unavailable for this book. The card above was sent in 1949 by a woman who was having a "nice trip. Wm. D. is working and I am loafing around."

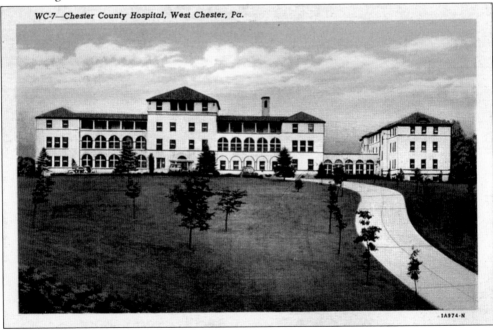

WC-7—Chester County Hospital, West Chester, Pa.

1A974-N

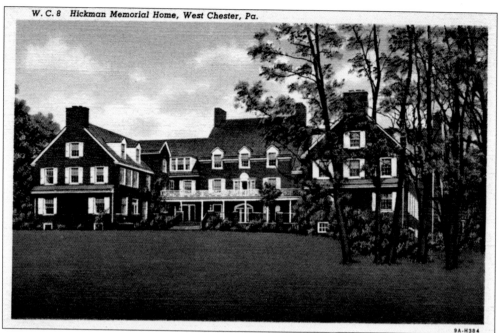

9A-H384

The eighth postcard in the Boyer series, above, depicts the Hickman Memorial Home in West Chester. Below is one of a series of line drawings from the first half of the 20th century. The postcard portrays the old Mansion House, at Church and Market Streets in West Chester. It states that the building had been a historic inn and hotel for more than 120 years and was once a stagecoach terminus for travelers.

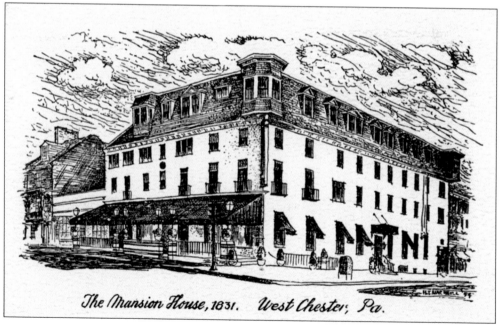

The Mansion House, 1831. West Chester, Pa.

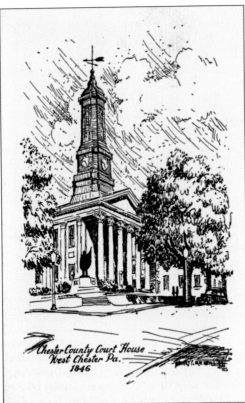

Chester County Court House West Chester Pa. 1846

The postcard of the Chester County Courthouse (left) reads, "The first court sessions at Turk's Head, renamed West Chester in 1788, were held in 1846." The postcard of the First Presbyterian Church (below) states, "The church was founded in 1834 and for more than a century its members have worshipped there. Its exterior is of Grecian architecture, the interior of early Colonial. The chapel was added in 1893."

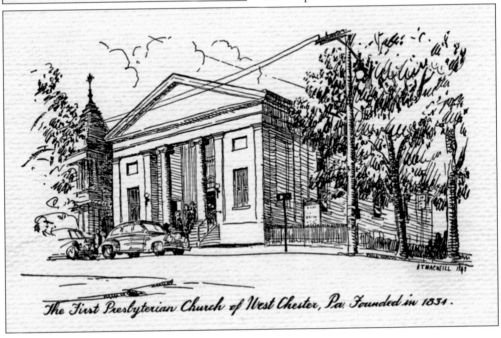

The First Presbyterian Church of West Chester, Pa. Founded in 1834.

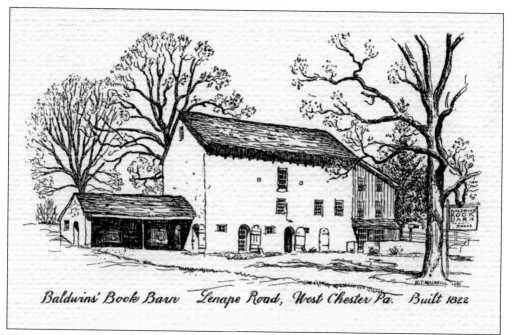

Baldwins' Book Barn Lenape Road, West Chester Pa. Built 1822

These two line-drawing postcards are of buildings just outside the borders of West Chester but still associated with the town. Above is Baldwin's Book Barn on Lenape Road. The postcard states, "Built in 1822. Now the home of a renowned Book Mart selling and buying rare and second-hand books of all kinds." The below postcard of Strode's Mill reads, "Built in 1721, on land granted to Arthur Cook by William Penn in 1686. Used as a grist mill by the Strode family for 150 years."

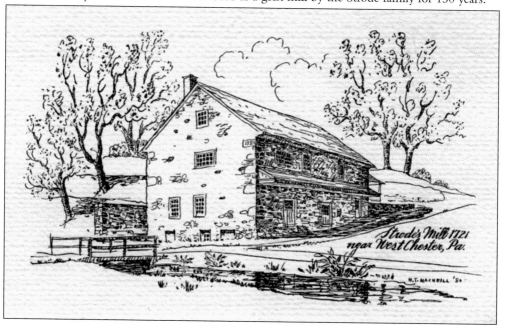

Strode's Mill 1721 near West Chester, Pa.

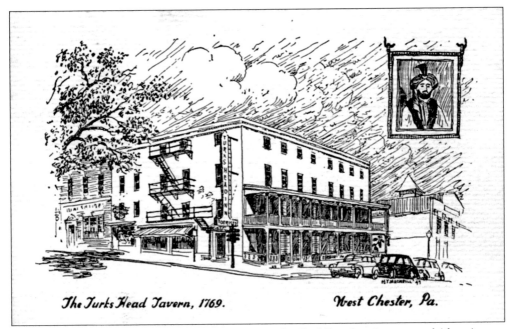

The Turks Head Tavern, 1769. West Chester, Pa.

THE BUILDINGS OF THE CHESTER COUNTY HISTORICAL SOCIETY

BRINTON 1704 HOUSE

HOPPER LOG HOUSE
1750 1800

DAVID TOWNSEND HOUSE
1790-1830-1849

MUSEUM AND LIBRARY

WEST CHESTER, PENNSYLVANIA

The final line-drawing postcard (above) depicts the Turk's Head Tavern with a date of 1769. A drawing of the tavern sign is included. The card states, "The history of this tavern dates from 1762, and gave its name to the town 'Turk's Head' until 1788. During the Revolution, it was used by scouting parties and as a hospital." The postcard to the left shows structures owned at the time by the Chester County Historical Society.

These two postcards are connected to the Chester County Historical Society. Shown above is Horticultural Hall, designed by architect Thomas U. Walter and the center of activity in the mid-1800s. Uriah Hunt Painter later converted the building into the West Chester Opera House, and still later it became a Grand Army of the Republic meeting place. The painting for the postcard is by Barclay Rubincam. The postcard below advertises an activity at the historical society.

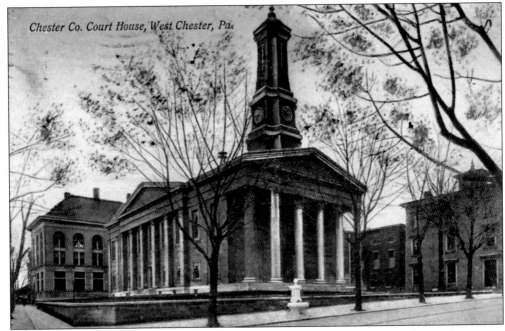

Chester Co. Court House, West Chester, Pa.

The Chester County Courthouse and the Old Glory monument are two subjects that appear on many postcards of West Chester. Postmarked 1908, the above card shows the area before the monument was erected. Seen below, the monument was dedicated on Memorial Day 1915 and erected "in grateful commemoration of the heroism, sacrifices and patriotism of her soldiers, sailors and marines displayed in the late war of the rebellion for the preservation of the Union and the supremacy of the flag."

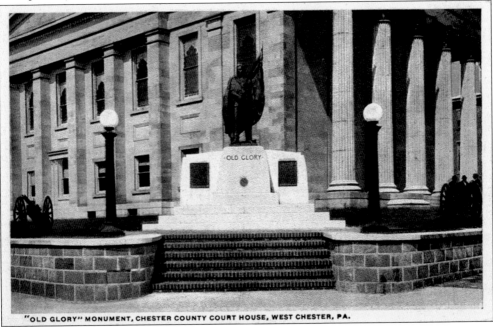

"OLD GLORY" MONUMENT, CHESTER COUNTY COURT HOUSE, WEST CHESTER, PA.

The physical look of the courthouse has changed over the years. When an annex was added, a courtyard was constructed in the space between the two buildings. As shown in the above postcard, the courtyard includes a fountain. Below, the intersection of Market and High Streets is busy with people and a horse-drawn buggy. The card is postmarked 1906.

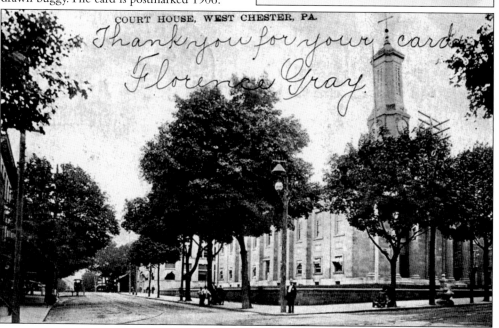

COURT HOUSE, WEST CHESTER, PA.

Thank you for your card

Florence Gray.

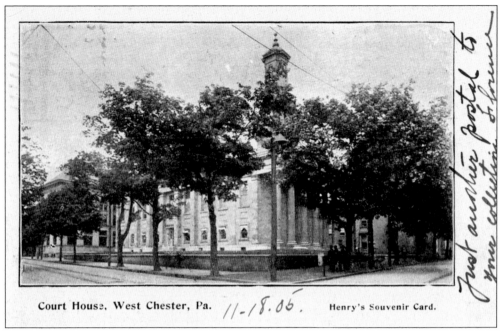

Court House, West Chester, Pa. 11-18.06. Henry's Souvenir Card.

Just another postal to your collection, Florence

The Henry's Souvenir Card was popular at the dawn of the 20th century. Postcards have been collected since printing began; the note on Henry's above view of the courthouse reads, "Just another postal to your collection, Florence." The below postcard was sent the next year, 1906, and clearly shows the trolley tracks that ran to the west on Market Street and turned south toward Wilmington, Delaware.

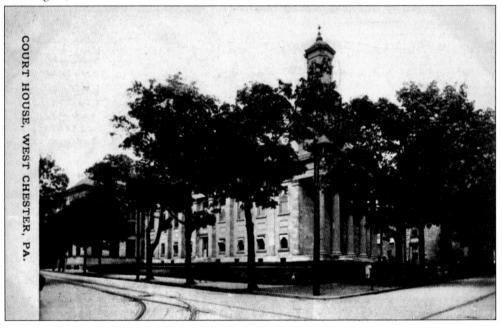

COURT HOUSE, WEST CHESTER, PA.

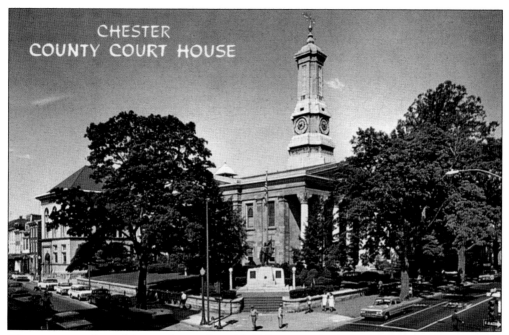

The two postcards on this page date to the mid–20th century, both showing street scenes and clear views of the courthouse's clock tower. The clock has chimed the time for those in West Chester for many decades. Below, the old Turk's Head Inn is clearly visible. The new Turk's Head Inn stands a half-block south of the old structure.

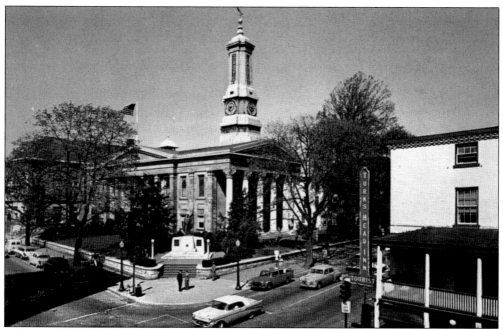

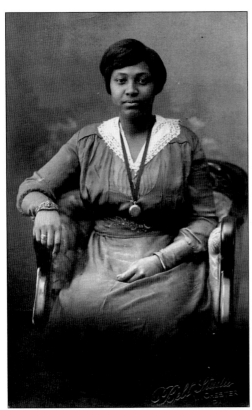

The name of the woman seated in the photo postcard to the left is unknown. The photograph was taken in West Chester at the Bell Studio and later turned into a postcard, as many were during the early part of the 20th century. The below card, depicting the Brandywine Grange Hall in Chester County, was produced by S. J. Parker and Son of West Chester.

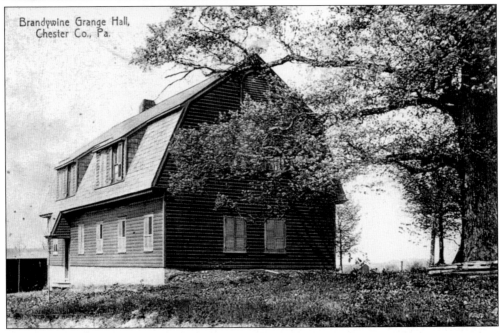

Brandywine Grange Hall,
Chester Co., Pa.

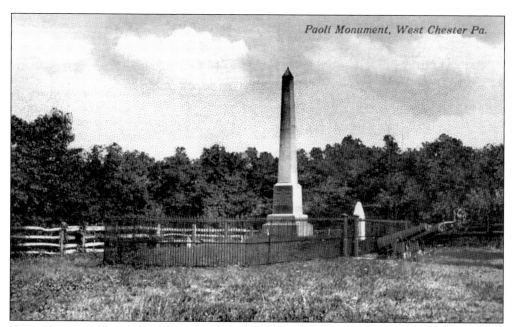

Paoli Monument, West Chester Pa.

West Chester is a recognizable community in the Chester County region and is mentioned as the location on many postcards even though the image might not actually be a spot within the borough's borders. The two postcards on this page, one made in New York City and the other in Philadelphia, list West Chester as the reference. Above, the Paoli Monument is really sited in Malvern at the scene of the American Revolutionary battle. Below, the postcard is titled "Old Octagonal Schoolhouse, Newton Square, West Chester, Pa." It should read, "Newtown Square." The site is not in West Chester.

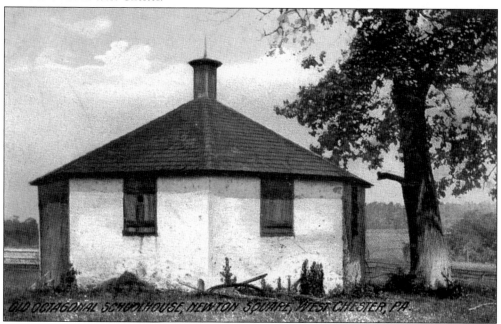

OLD OCTAGONAL SCHOOLHOUSE, NEWTON SQUARE, WEST CHESTER, PA.

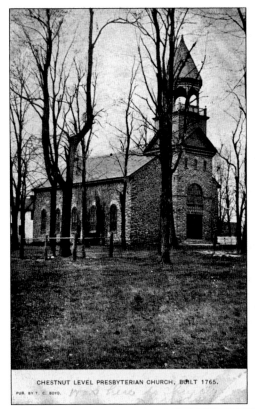

CHESTNUT LEVEL PRESBYTERIAN CHURCH, BUILT 1765.

PUB. BY T. C. BOYD.

Two other postcards with West Chester designations appear here. The view to the left shows the Chestnut Level Presbyterian Church, built in 1765. The card was mailed from West Chester in 1908, and a dealer labeled it as a West Chester postcard. The church is actually located in Quarryville in Lancaster County. The below postcard, published by Horace F. Temple, is a "view from tennis courts" with no other information.

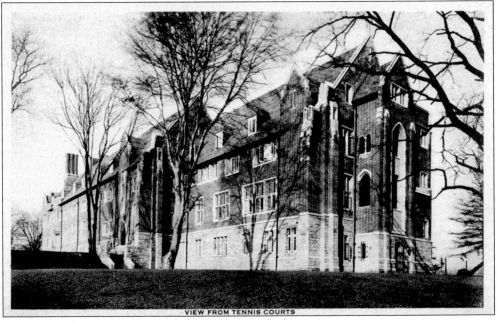

VIEW FROM TENNIS COURTS

West Chester celebrated its bicentennial
in 1999, and as part of the festivities, a
postcard series was authorized by the
committee, printed, and distributed. The
views on this page include an interior
photograph of St. Agnes Church on
West Gay Street (right) and the gazebo at
Everhart Park (below). On March 28, 1799,
the Pennsylvania Assembly passed an act
incorporating West Chester as a borough.

The bicentennial committee series of authorized postcards included views of the West Chester Fire Company and the West Chester Library building, both shown here. In 1799, the year of the incorporation of West Chester as a borough, the First West Chester Fire Company was established. It covered the whole borough, which at the time measured one square mile.

Eight

PARKER POSTCARDS

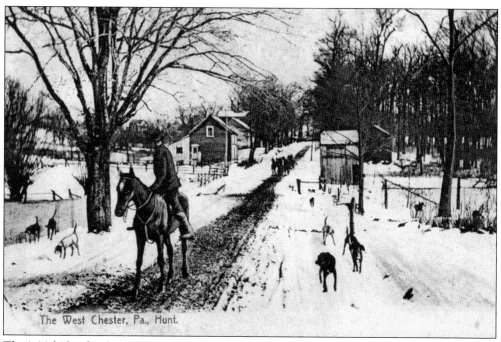

The West Chester, Pa., Hunt.

The initial idea for this book on the West Chester area was one exclusively containing S. J. Parker and Son postcards. Parker cards were known to be of high quality throughout the area. The postcards in this final chapter were all produced by Parker and are views in and around West Chester and neighboring Chester County communities. Shown here is the West Chester Hunt.

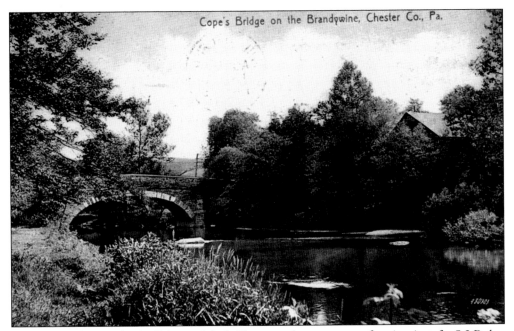

Cope's Bridge on the Brandywine, Chester Co., Pa.

Scenes along the Brandywine River and the bridges over the stream were favorite views for S. J. Parker and Son and many other postcard manufacturers. The postcard above shows the Brandywine at Cope's Bridge, while the one below reveals not only the river but also the Brandywine Road leading out of West Chester.

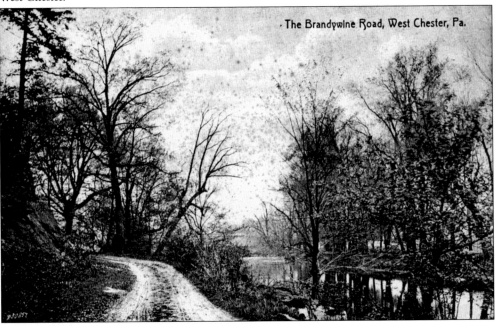

The Brandywine Road, West Chester, Pa.

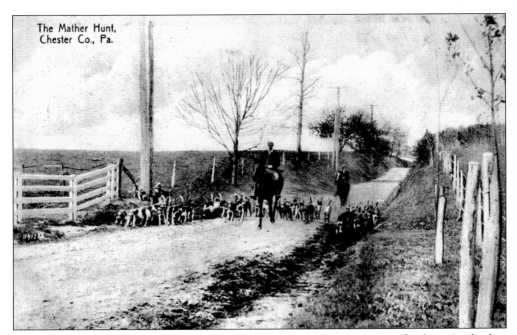

The Mather Hunt,
Chester Co., Pa.

West Chester was one of many Chester County communities to have a fox hunt in the late 19th and early 20th centuries. The West Chester Hunt is shown on page 111 of this book. The postcard above depicts the county's Mather Hunt. Travelers heading west from West Chester on the Strasburg Road encounter the Brandywine Bridge at Mortonville, pictured below.

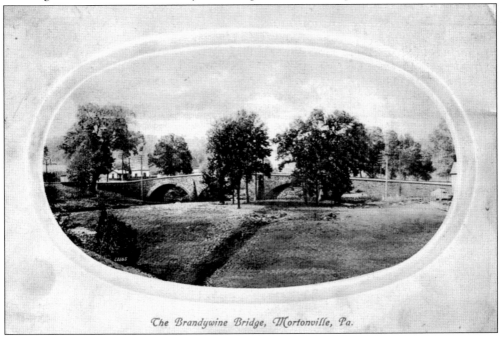

The Brandywine Bridge, Mortonville, Pa.

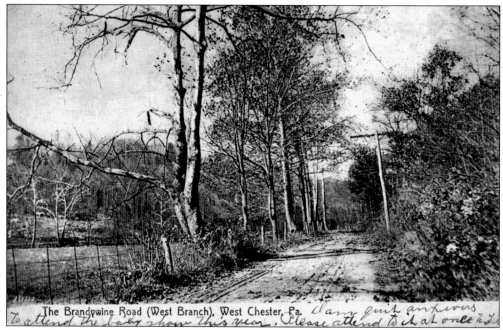

The Brandywine Road (West Branch), West Chester, Pa. *I am quite anxious to attend the baby show this year. Please attend to it at once & I.*

During the late 19th and early 20th centuries, the roads heading west from West Chester were often narrow pathways, many carved out during the times American Indians inhabited the area. These S. J. Parker and Son cards are views of the Brandywine Road. The one above states that the road is running by the West Branch of the Brandywine River. The card below shows the road near Mortonville.

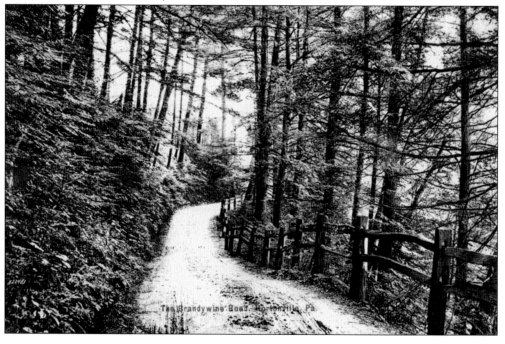

The Brandywine Road, Mortonville, Pa.

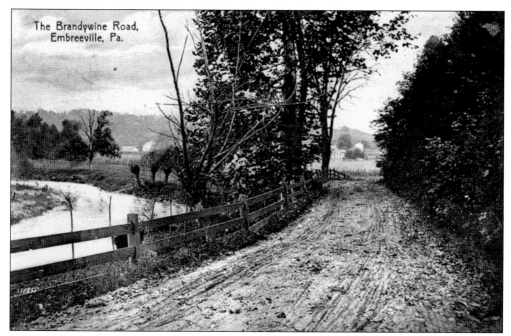

The Brandywine Road,
Embreeville, Pa.

The Brandywine River has two branches, with the east being the one closer to West Chester. The East Branch begins in the Honey Brook area of Chester County and runs through Coatesville, joining the West Branch south of West Chester. These two postcards show the West Branch near Embreeville along the Brandywine Road.

The Brandywine road, Embreeville Chester Co., Pa.

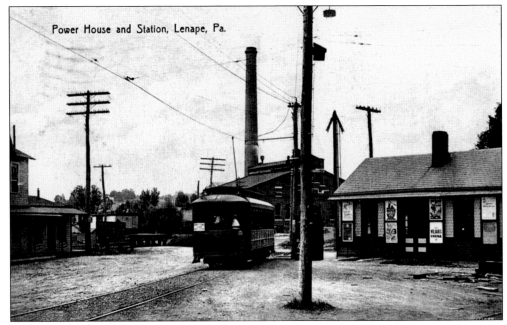

Power House and Station, Lenape, Pa.

West Chester was connected to Lenape, which is along the Brandywine River, by a trolley in the early 20th century. The area is still home to an amusement park that is more than a century old. Lenape has always had businesses employing West Chester residents, including the powerhouse and station (above) and Sager's Mill (below).

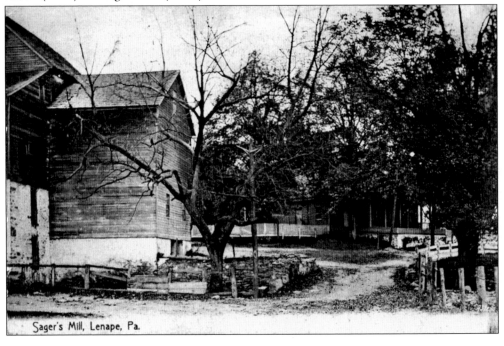

Sager's Mill, Lenape, Pa.

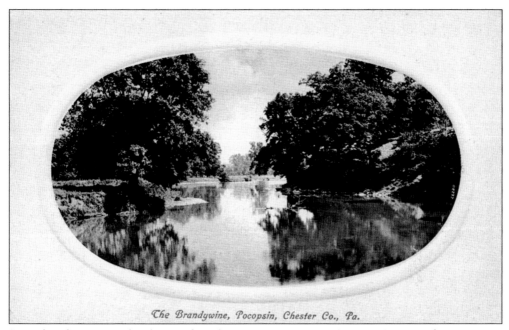

The Brandywine, Pocopsin, Chester Co., Pa.

Samuel Parker operated a dry goods and notions store at 19 West Gay Street at the same time that the company was publishing postcards of the West Chester region. His early cards—that is, those produced before 1907—had a plate number on the front, while the remaining cards were numbered on the back. These two postcards of the Brandywine were produced after 1907 and were numbered 145 (below) and 307 (above).

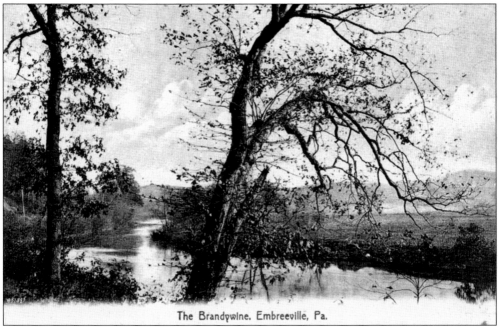

The Brandywine. Embreeville, Pa.

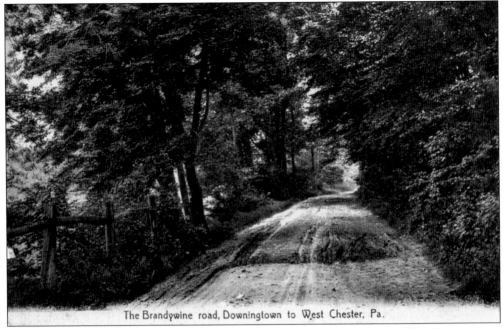

The Brandywine road, Downingtown to West Chester, Pa.

The East Branch of the Brandywine River travels through Downingtown to West Chester. Seen in the above postcard is the Brandywine Road between the two villages. Downingtown had an opportunity to become the seat of Chester County government but declined because its residents believed the designation would bring too much traffic. The below card shows the Brandywine outside of West Chester.

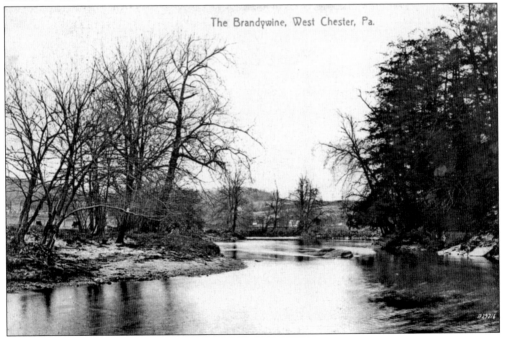

The Brandywine, West Chester, Pa.

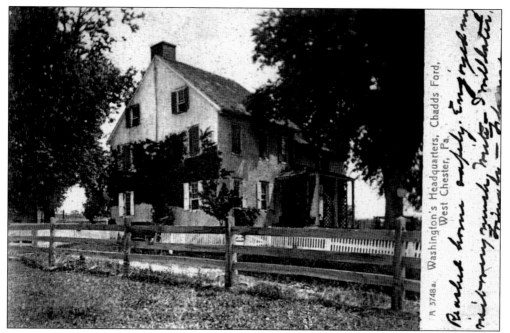

The West Chester area, including the Brandywine River, is a historic section of the country where the largest land battle of the American Revolution, the Battle of Brandywine, was fought. The battle raged on September 11, 1777, just south of West Chester, and the wounded were treated at Turk's Head. The above postcard shows Washington's headquarters, and the one below is titled "Chadd's House, Chadd's Ford, Pa., Scene of Battle of Brandywine, Sept. 11, 1777."

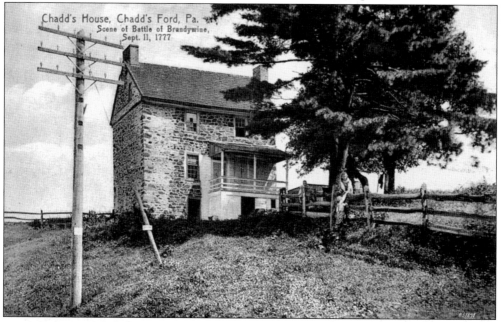

Chadd's House, Chadd's Ford, Pa.
Scene of Battle of Brandywine,
Sept. 11, 1777

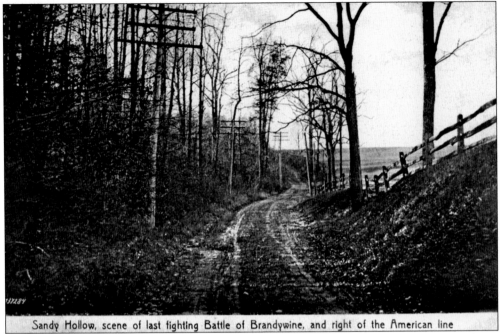

Sandy Hollow, scene of last fighting Battle of Brandywine, and right of the American line

Late in the afternoon of September 11, 1777, some of the fiercest fighting of the Battle of Brandywine took place at Sandy Hollow, pictured above. At this spot, American soldiers stood their ground against the British regulars and gained the much needed confidence that they could beat the British professional army. The postcard below shows one of the fords the British crossed to outflank George Washington's army.

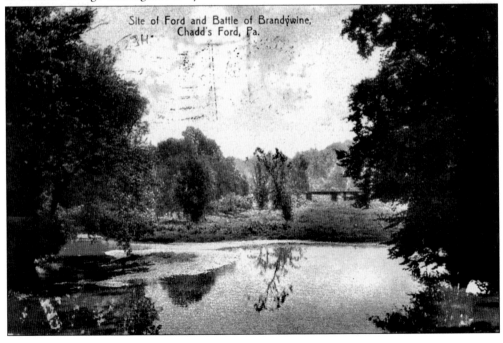

Site of Ford and Battle of Brandywine,
Chadd's Ford, Pa.

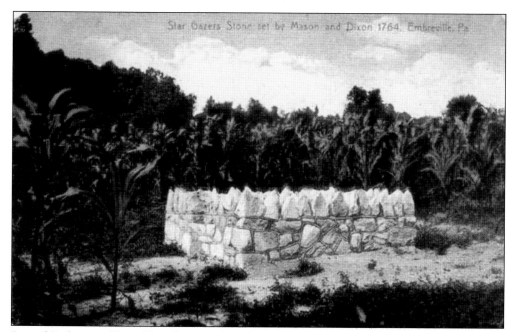

Star Gazers Stone set by Mason and Dixon 1764, Embreeville, Pa

Samuel Parker would send his photographers from his West Chester store throughout the region to take photographs of scenes he wanted reproduced. Because Germany had the best process for postcards at the dawn of the 20th century, the photographs were sent to Germany for processing. The scenes on this page are of the Star Gazers Stone in Embreeville used by Mason and Dixon and the ford below Chadds Ford where the Pennsylvania militia was stationed during the Battle of Brandywine.

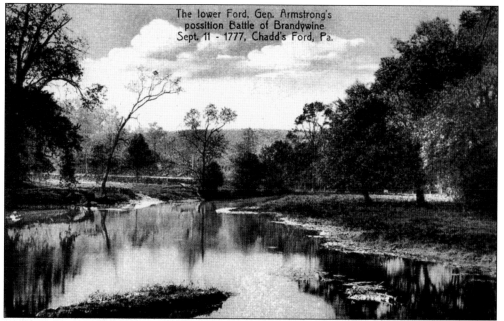

The lower Ford, Gen. Armstrong's possition Battle of Brandywine. Sept. 11 - 1777, Chadd's Ford, Pa.

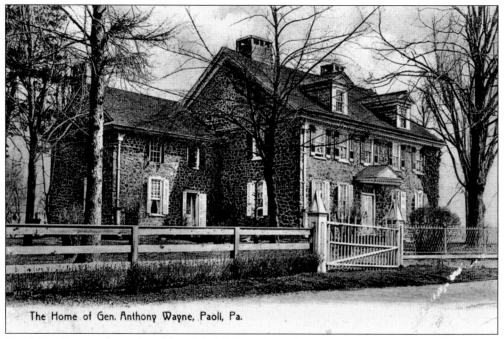

The Home of Gen. Anthony Wayne, Paoli, Pa.

Turk's Head was in the midst of the Philadelphia campaign in the fall of 1777. Besides the Battle of Brandywine, the Battle of Clouds was almost fought on the fields of East Goshen, just a few miles east of town. The battle did not take place because a rain storm ruined the armies' ammunition. Gen. Anthony Wayne was in charge of American forces at the battle of Paoli. Wayne's home is pictured above, and the headquarters of Generals DeKalb and Weedon at Valley Forge is seen below.

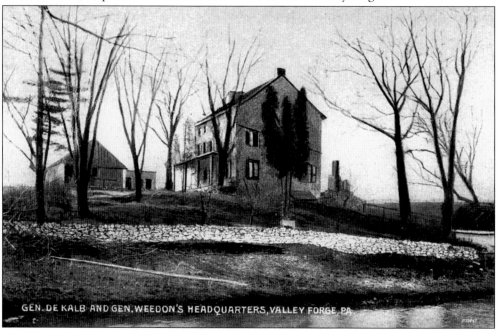

GEN. DE KALB AND GEN. WEEDON'S HEADQUARTERS, VALLEY FORGE, PA.

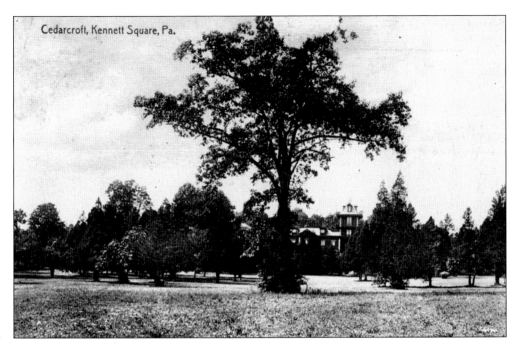

Cedarcroft, Kennett Square, Pa.

Samuel Parker also sent his West Chester photographers to record the scenes connected with famous writers of the era and area. The postcard above shows the Cedarcroft, Kennett Square, home of Bayard Taylor, an internationally known writer of the 1800s. The view below depicts the residence of Thomas Buchanan Read, who authored the Civil War work *Sheridan's Ride*.

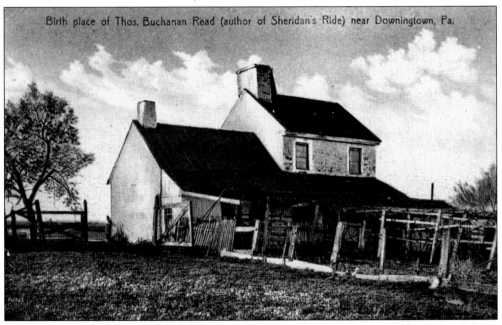

Birth place of Thos. Buchanan Read (author of Sheridan's Ride) near Downingtown, Pa.

Cedarcroft School, Kennett Square, Pa.

Samuel Parker sent detailed instructions to Germany along with the photographs of the postcard scenes. The instructions dealt with the shading of the trees and the skies along with roads and homes. Despite the instructions, many times the cards were not produced to Parker's specifications. The two on this page show how extremely difficult the scenes are to shade. Cedarcroft appears above, and Brandywine Road below.

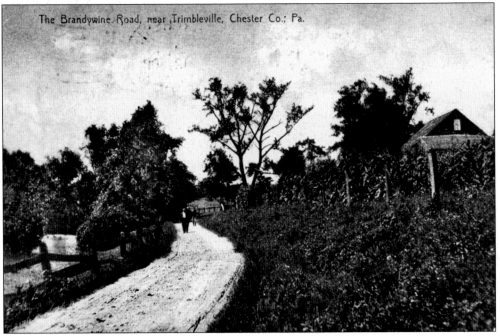

The Brandywine Road, near Trimbleville, Chester Co., Pa.

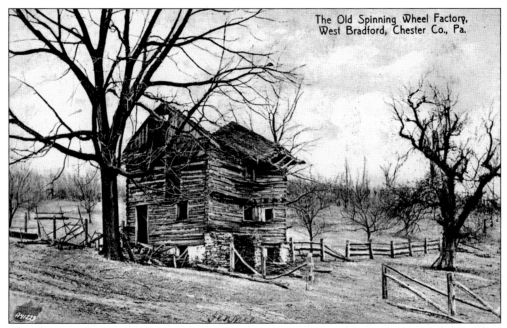

The woman who sent the above postcard was attempting to set up a family gathering with a relative in Atglen, a community at the western end of Chester County. The postcard she chose for the correspondence shows the "Old Spinning Wheel Factory," just west of West Chester. The below postcard is of the mineral springs in Chester Springs.

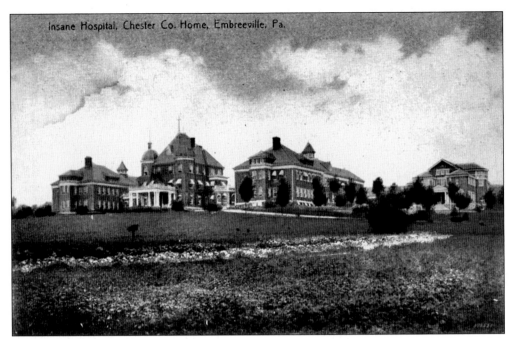

Insane Hospital, Chester Co. Home, Embreeville, Pa.

The postcards of the early 20th century are a pictorial history of the times. S. J. Parker and Son captured the present and scenes of the past, as illustrated on this page. Above is the new, at the time, "insane hospital" located a few miles west of West Chester. Below, the roof is falling down at the Old Kennett Meeting House.

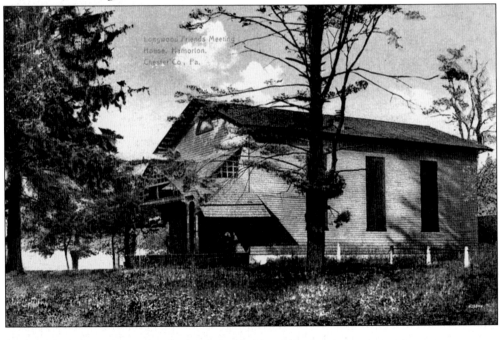

Longwood Friends Meeting House, Hamorton, Chester Co., Pa.

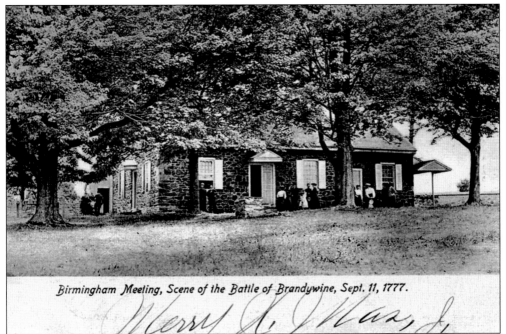

Birmingham Meeting, Scene of the Battle of Brandywine, Sept. 11, 1777.

The Society of Friends, better known as the Quakers, influenced life in West Chester, Chester County, and throughout Pennsylvania from the time of William Penn. S. J. Parker and Son recorded many of the meetinghouses of the area, including the two here. The above card shows the Birmingham Meetinghouse, just south of West Chester, and the one below shows the Uwchlan Meetinghouse, northwest of West Chester.

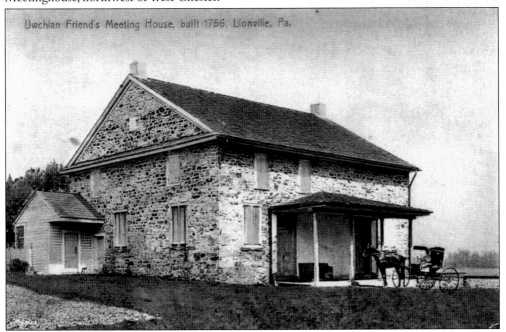

Uwchlan Friend's Meeting House, built 1756, Lionville, Pa.

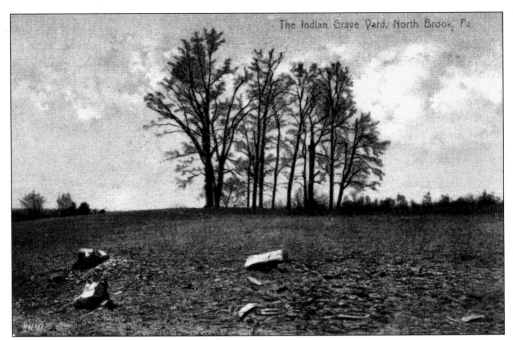

The Indian Grave Yard, North Brook, Pa.

West Chester has a rich history that predates the founding of the country. In the postcard above, S. J. Parker and Son recorded a scene that even predated the founding of Turk's Head. The view is of the "Indian Grave Yard." The final postcard of this book is Parker's rendition of a highly recognizable scene of the West Chester area: Cope's Bridge over the Brandywine River.

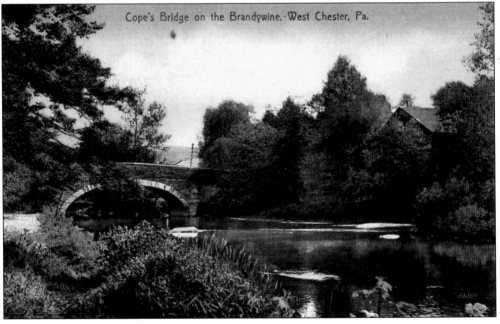

Cope's Bridge on the Brandywine, West Chester, Pa.